SOHAM
& WICKEN

THROUGH TIME

Michael Rouse *&* Anthony Day

AMBERLEY PUBLISHING

Acknowledgements

My thanks to Anita and Reg Brown for use of their vast archive of local history, also to John Martin for information about 'The Bush' and East Fen Common. Over the years I have acquired information and photographs from many different sources and I thank them all.

Especial thanks to Josh Martin and his family, to Lauren and Cassie for braving that horse near Loftus Bridge and for all those home or shop owners who posed outside their premises. Thanks to Anthony Day for inviting me to contribute the Soham section and to Amberley and Sue Ross for guiding us along the way.

Michael Rouse

The vintage photographs of Wicken are from the archive formed by the author over the last forty-five years, and are destined to enter the Cambridgeshire Collection at the Lion Yard Library in the near future. The exceptions are the two views of Thorn Hall kindly lent by Mr and Mrs Peter Fuller.

Anthony Day

First published 2009

Amberley Publishing Plc
Cirencester Road, Chalford,
Stroud, Gloucestershire, GL6 8PE

www.amberley-books.com

Copyright © Michael Rouse and Anthony Day, 2009

The right of Michael Rouse and Anthony Day to be identified as the authors of this work has been asserted in accordance with the Copyrights, Designs and Patents Act 1988.

ISBN 978 1 84868 667 0

British Library Cataloguing in Publication Data.
A catalogue record for this book is available from the British Library.

Typeset in 9.5pt on 12pt Celeste.
Typesetting by Amberley Publishing.
Printed in the UK.

Introduction

Soham and Wicken have been inextricably linked for centuries. Soham, the smallest town or the largest village in England by local repute, lies but two miles away by green footpath or four miles round by road, their native populations linked by marriage for generations.

In our time, however, the native populations have continued to decline along with employment opportunities. Wicken today is a commuter village, so few are able to work on home ground, such as can be said for many another of its size. It is famous for its expanse of primeval fen, the retention of which against the seventeenth-century drainage scheme was wholly due to the determination of the villagers who relied upon it for sustenance and heating.

In 1638, when the great drainage scheme for the fens was underway, the villagers banded to convince the two King's messengers, come to persuade them to give up their cause, to turn back and leave them and their fen alone. This the messengers did and the fen, their source of wildfowl, fish, peat-turves, reeds and sedge, was left for them, their cause greatly helped by the resident Justice of the Peace, Isaac Barrow and the local curate, Robert Grymer, both Royalists who believed in their cause. No man was ever arraigned for his part in this small rebellion.

Wicken Fen was used by the locals for harvesting sedge and reeds until the National Trust put a stop to it in the 1920s, while peat was dug nearby until the Second World War. The fen was then consigned to naturalists but today it is a draw for thousands of people a year, which rather goes against the original ideal of a wildlife sanctuary. Wicken is, indeed, separate from its fen today.

If the number of dwellings in the village has risen it has not increased the size of the population. Houses once divided into two or three homes now hold one, but the loss in old thatched houses

shows up vividly in the photographs of our finest photographer, Emma Aspland, who clearly anticipated their going. Just some remain, superbly restored, and are ironically the most coveted in our time. Many new dwellings have gone up here since the war, the latest a block of eight homes under four roofs intended as starter homes but denied to the locals by a greater authority. I show them, ironically, as a backcloth to the site of John Hawes' home c. 1900.

The village, like many another of its size, has lost so many of its facilities and services. Once the village primary school closed in 1992 the last provision stores soon succumbed and at this time we have but one small butcher's shop and the supermarkets at Soham, Ely and Newmarket. But the village is cherished by the majority who live in it and are prepared to ignore the volume of heavy traffic going through.

So we share more and more with Soham, including the vicar, the doctors and the schools, which are of high reputation. We are in harmony and it was always thus.

<div style="text-align: right">Anthony Day</div>

Soham today is looking to the future through a new vision, embodied in a masterplan. Change will happen, more growth will come. Those who say they want nothing to change will only have to look through these photographs to see how much Soham has changed in the seventy or so years since horses came down the High Street to be shod at my grandfather's forge and the town had a population of under 5,000.

The small shops that were scattered throughout the town have mostly gone, as have the numerous public houses. The drapers and shoe shops have given way to fast food outlets. All the children no longer walk to school, they arrive in their hundreds in buses or cars. The most noticeable change in some of the street scenes is the number of cars and the clutter of street furniture. Where once Soham was firmly rooted in the surrounding farmland, now the population travels further to work in other employment. Soham today, with a population of just under 10,000, has been opened up to the outside world much more, with many people living in the town who have their roots elsewhere. This book is for those new to the town and for those who can still remember. It is also for those who in the future may look back on today's photographs with some twinge of nostalgia.

<div style="text-align: right">Mike Rouse</div>

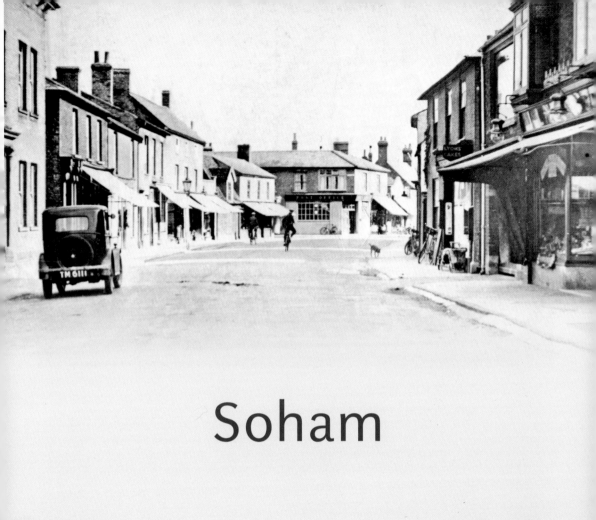

Soham

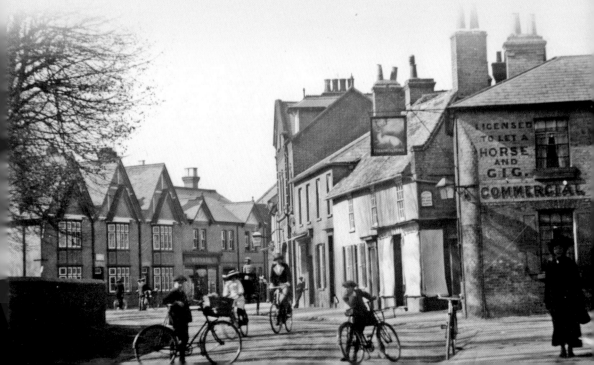

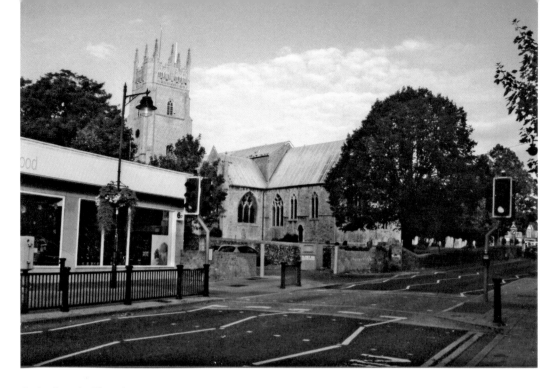

St Andrew's Church

Soham had its origins as a Saxon settlement. It is said that St Felix founded a religious community in AD 630. The beautiful church of St Andrew was begun by the Normans in 1102, incorporating some of the earlier Saxon building. Olaudah Equiano, known as Gustavus Vassa, 'The African', was married to Susannah Cullen in the church in 1792. There is a stained glass window dedicated to Revd William Case Morris, the Dr Bernardo of the Argentine, who was born in Soham in 1864.

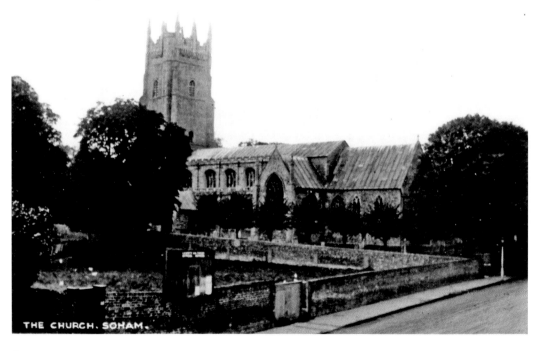

THE CHURCH, SOHAM.

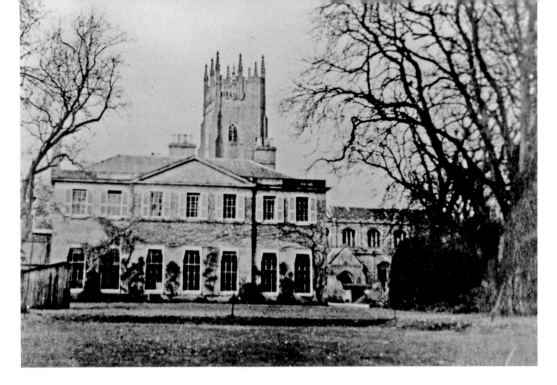

St Andrew's Vicarage c. 1910

The magnificent vicarage for St Andrew's was built in 1720 and enlarged in about 1834. The Reverend Cyprian John Rust was vicar of Soham for fifty-three years; then the Reverend Boughey lived here from 1927 to 1953. The large gardens were a popular place for garden parties. In 1954 the vicarage moved to the former home of the Slack family on Cross Green. St Andrew's House became flats and has recently been renovated with new houses built in the gardens.

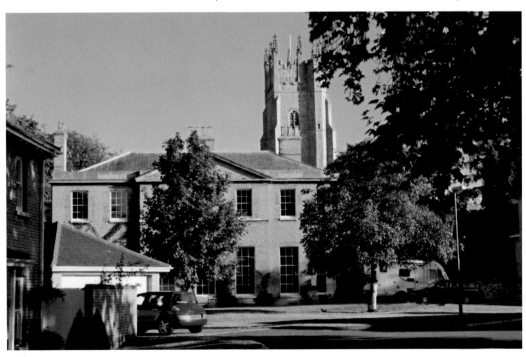

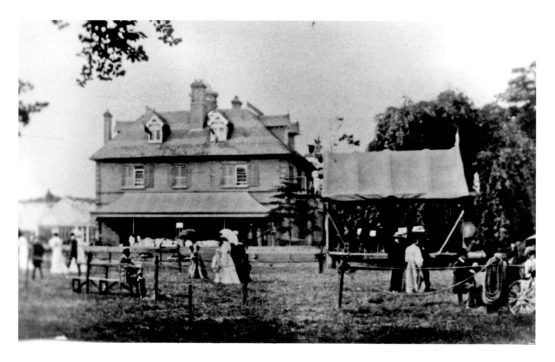

The Place

The Place was an imposing house with extensive grounds next to St Andrew's church. The grounds were a popular venue for garden parties. In 1925 it ceased to be a private house and a number of building plots were sold around the edge. In 1928, after the house had been reduced to a single storey, the parish council bought it and the rest of the land for a pavilion and recreation ground. The annual Pumpkin Fair in late September is always a popular event.

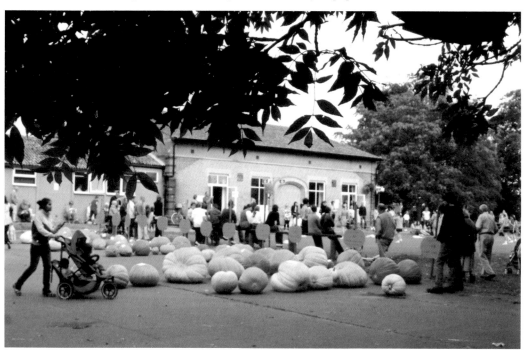

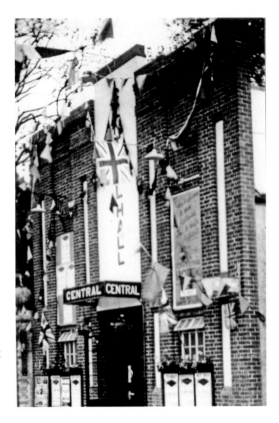

The Central Hall, 1935

The Central Hall in Fountain Lane was built in 1931 as a music hall. This photograph dates from when it had become a cinema, possibly at the time of the royal silver jubilee of 1935. The Central Hall did not survive long as a cinema, there was already the Regal in Clay Street and in 1939 the New Regent opened almost opposite the Regal. The Central Hall finally became a kitchen and bathroom centre but burnt down in 1981. It is now the site of a private house.

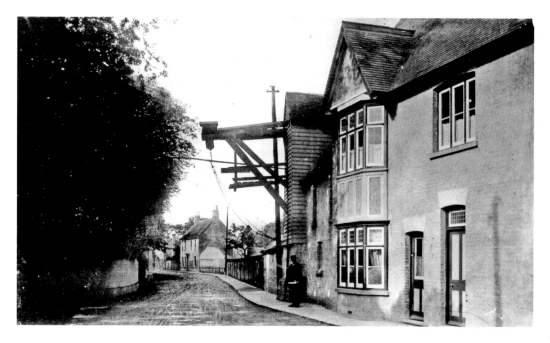

The Steelyard Arm

Fountain Lane showing the trees from the grounds of 'The Place' on the left and the historic steelyard arm next to the Fountain pub. The steelyard arm was fortunate to survive the Fountain's fire of 1900 and is one of only two in the country. It was used for weighing carts and waggon loads of hay or straw until 1879 when the Ely to Newmarket railway line opened and a new weighbridge was installed at Newmarket.

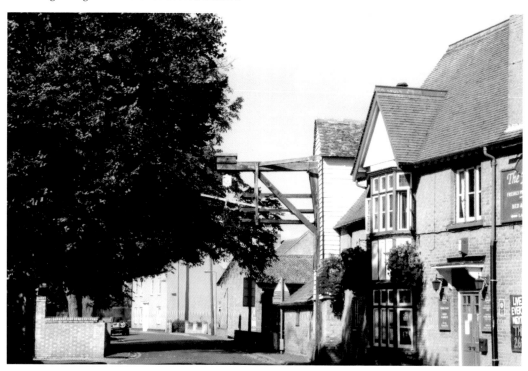

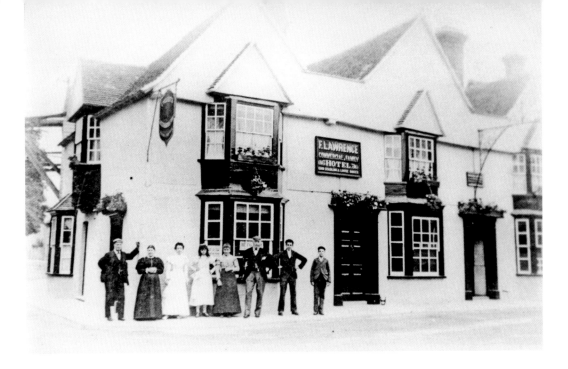

The Fountain Inn c. 1895

The original Fountain commercial and family hotel, seen here in the 1890s when the Lawrence family ran it, was burnt to the ground in a disastrous fire on 4 May 1900. My grandfather was one of the firemen who fought to save it. Later he had a presentation half sovereign inscribed with the name and date mounted for his watch chain. The Fountain was rebuilt in very similar style to the original. A fireplace in the lounge that survived the fire is dated 1533.

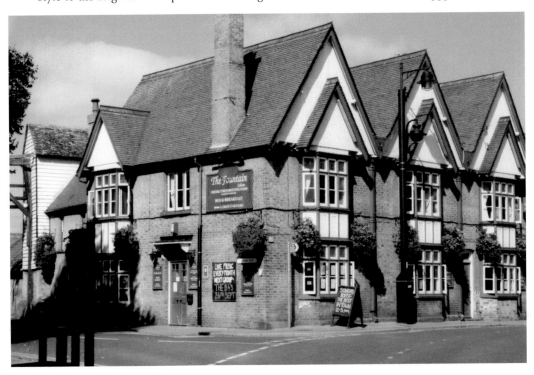

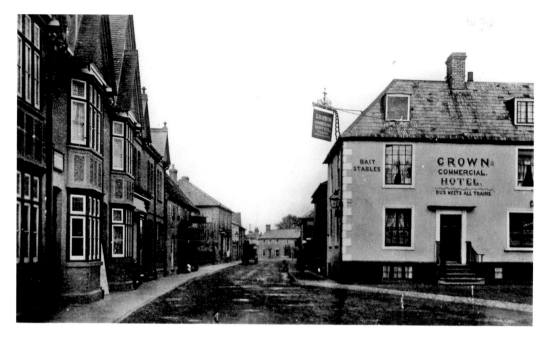

The Crown and Churchgate Street

Churchgate Street with the Fountain and the Crown public house in the market place around 1912. The market place in front of the pub was a popular spot for a Saturday evening bit of sport. As men left the pub one would call from the top of the steps, 'Let's see who's the best man here!' And that would signal a free-for-all fist fight. The Crown became a private house in the late 1960s.

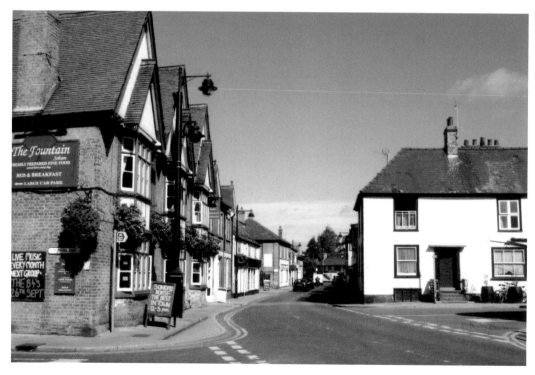

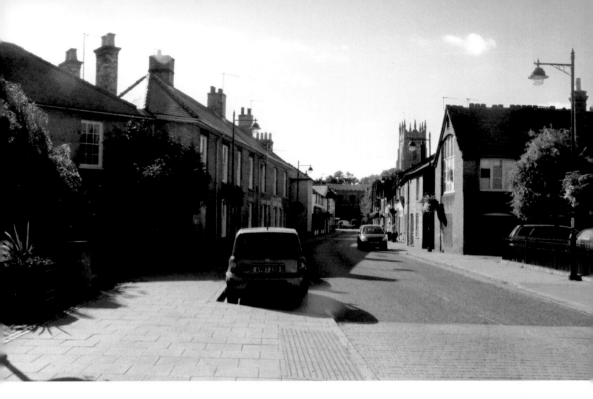

Churchgate Street

Churchgate Street from Cross Green. On the left is the present vicarage for St Andrew's and on the right can be seen part of the old grammar school. Soham Grammar School was originally founded in 1686 and financed by the Free School Moor Charity. This building, now largely derelict, was built in about 1880 on an area called the Hempland and the site of the original school. In 1926 the school transferred to Beechurst on Sand Street.

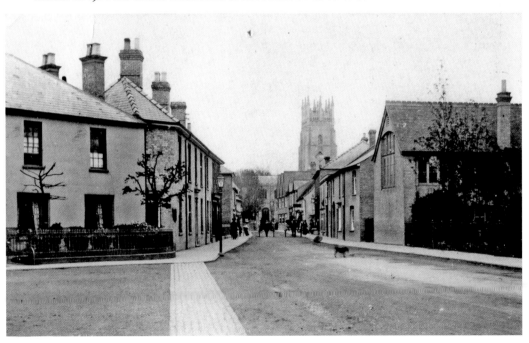

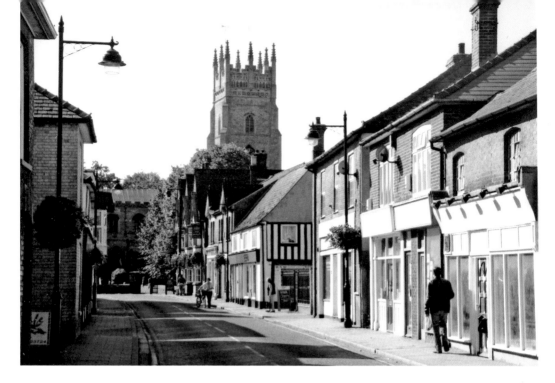

Churchgate Street

Churchgate Street showing the Saracen's Head. In the second half of the nineteenth century George Mainprice was a brewer in Soham with premises at the Saracen's Head. By 1896 Treadway and Percy owned the brewery and the public house. Reuben Long's corn merchants is in the foreground and beyond the pub was the shop that became Waddington's.

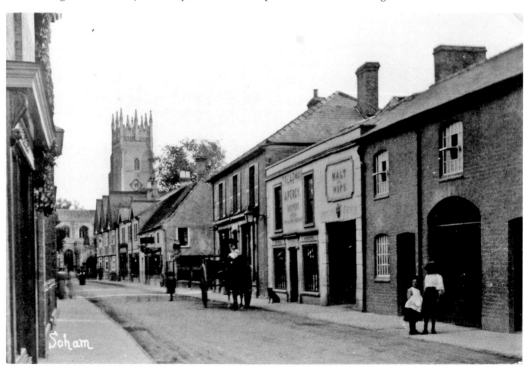

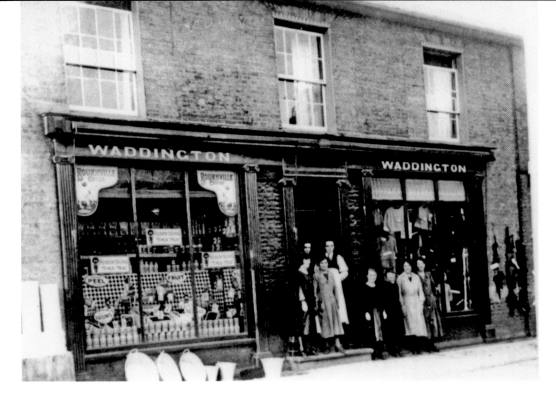

Waddington's Churchgate Street c. 1925

Richard Waddington stands in the doorway of his general store in the 1920s with Mrs Leek, Mrs Clark, Mrs Audus, Dolly Moore, Tiny Fordham, later Bullman, Gertie Leonard and Mrs Musk. Richard Waddington was one of the best known and most respected businessmen in the town. The shop closed in 1976 and became Fine Fare. Today Steven Leach stands outside his City Kitchens business that he has run there since 1994.

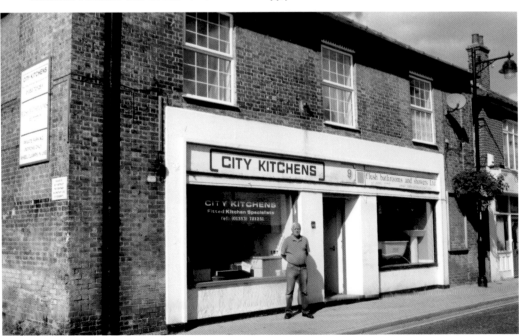

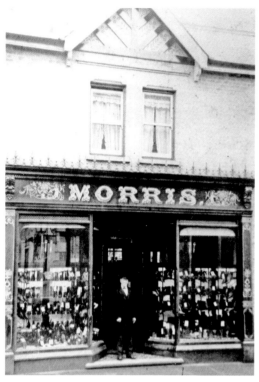

Morris, Churchgate Street *c.* 1910
James Morris was a boot and shoe maker
of Churchgate Street and High Street,
Soham, in Edwardian times and the
1930s. This is the Churchgate Street shop.
This shop eventually became a branch of
Monks of Mildenhall until Alison Muir
began her hairdressing business here in
1984. She stands in the doorway with her
staff of what is one of the most tastefully
maintained shop façades in the town.

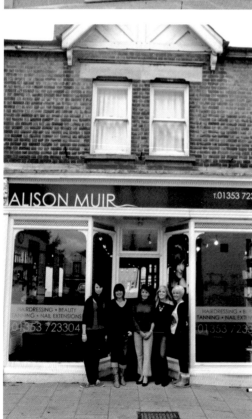

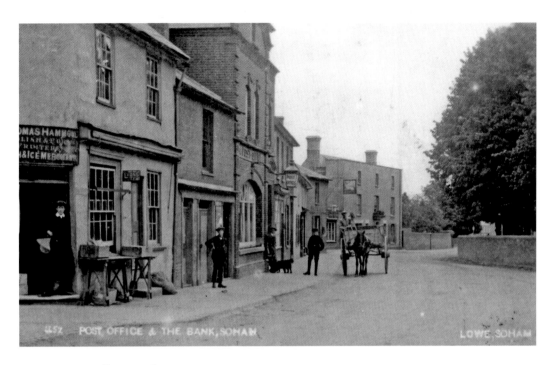

Hammond's c. 1906

Thomas Hammond's fishmongers stood on the comer of Market Place and Churchgate Street. The sign for the post office can be clearly seen where the horse and cart stand. The imposing building in the distance was the home of the Sudbury family until they sold it to Barclays Bank in 1906. A new bank was built alongside it in 1926 and the old house demolished in 1958. Today Hammond's is a residence, while the old post office is now Lloyds Bank.

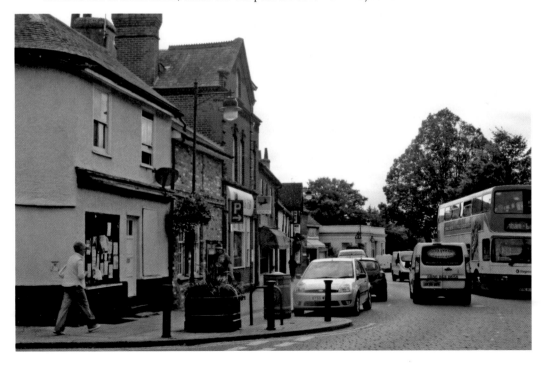

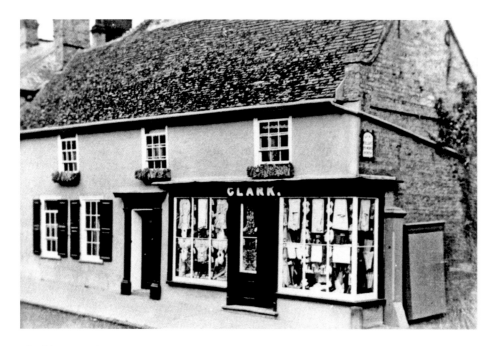

Clark's c. 1906

Miss Clark's fancy goods shop in Churchgate Street, sometime before 1912. Later the premises were well known as Staples' butchers shop. Staples bought the White Hart in 1937 to give them access to the rear of their property. In 1938, a room was built very skilfully over the entrance to the courtyard. For a while the building was Soham Pottery and until very recently the charming Poppies restaurant and the Churchgate Inn. It now awaits a new use.

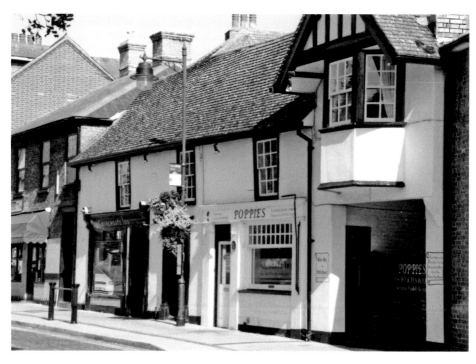

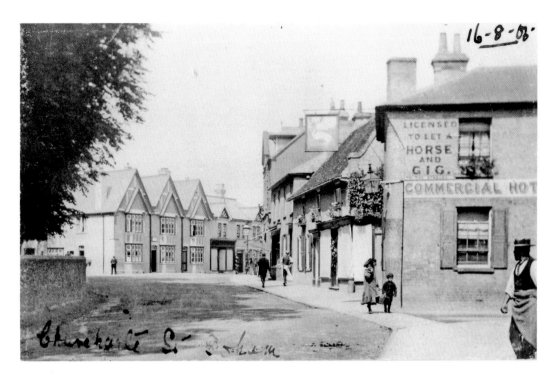

Churchgate Street

The corner of White Hart Lane from the High Street showing Clark's fancy goods shop and part of Churchgate Street. The painted signs on the White Hart can still be seen although the inn has long since been a private house. The sender of the card has added the date 16 August 1905 and was thanking Gertie for sending birthday wishes. Apart from the modern street furniture the view has changed little.

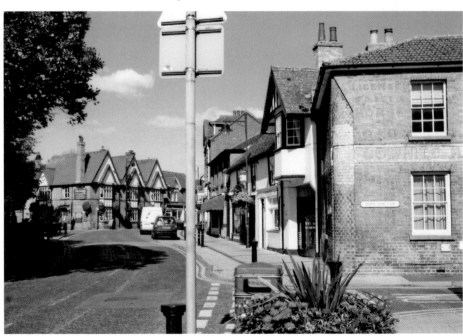

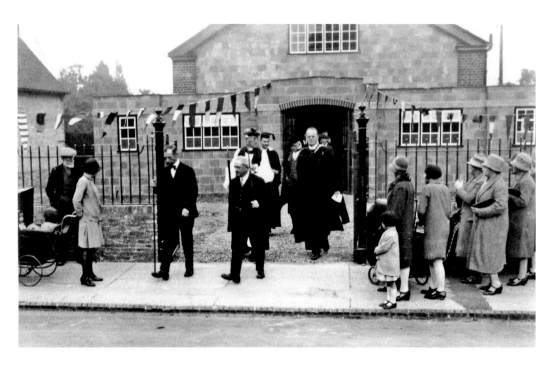

The Church Hall Opens 1929

In 1905 a fund was launched for a new church hall. In 1912 a site was bought on the High Street. In 1928 the new vicar, the Reverend P. F. Boughey, re-formed the scheme and the hall opened in October 1929. The vicar is in the gateway with the paper in his hand. After many years of popular use, the hall fell into disrepair and became an auction room. The church has now sold the hall to a local builder and the site awaits redevelopment.

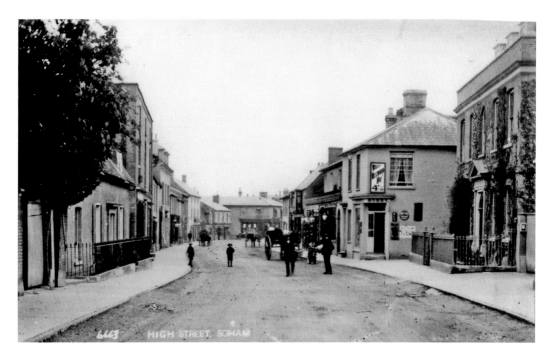

High Street

One of the best known shops in Soham was that of Bobby the Chemist, which, with its corner door, stood out prominently next to the doctor's house. Charles William Bobby was a herbalist and had a kiln for drying dandelions and other plants in Paddock Street just before the entrance to East Fen Common. My father, as a boy of about ten just before the First World War, remembered being paid by Mr Bobby to crawl inside and clean it out.

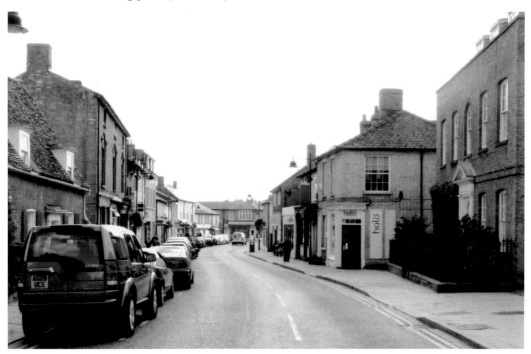

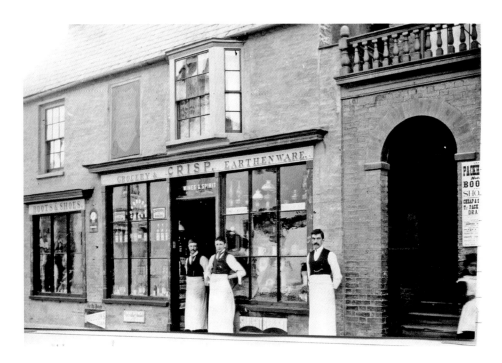

Crisps c. 1906

Crisps in the High Street, next to Bobby the Chemist. This is the epitome of the Edwardian business selling grocery and earthenware, boots and shoes. Thomas George Crisp's business had gone by 1916. Today the shop front is recognisable but, sadly, empty. The balustrade on the first floor has gone and, more's the pity, so has the delightful bay window which added such character.

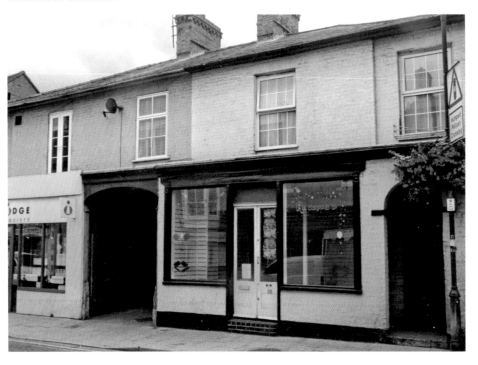

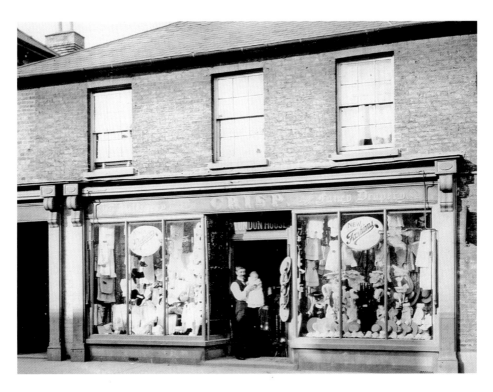

Crisp's Drapers *c.* 1906

Crisps had their draper's shop on the opposite side of the High Street. While the overall building is easily recognisable there have been changes at ground-floor level to create two separate shops. Where once the family owning the shop would usually live over it, now much of the first floor accommodation is let independently.

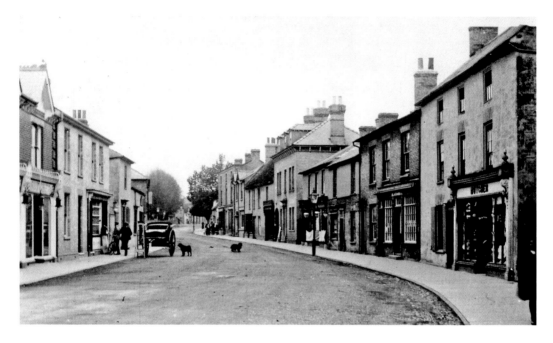

The High Street

An incredibly empty High Street in about 1913 or 1914. The shop of Francis Butcher, draper and tailor, can be seen on the right. The cart, without its horse, stands near Henry Rouse's forge. The horse is probably being shod. William Charles Rouse, his father and my great-grandfather, had bought the premises in 1869 with the cottage beside it. On William Charles' death in 1908, Henry moved from his forge in Fountain Lane to the High Street.

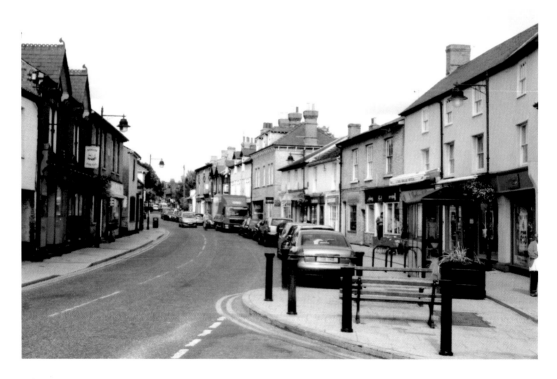

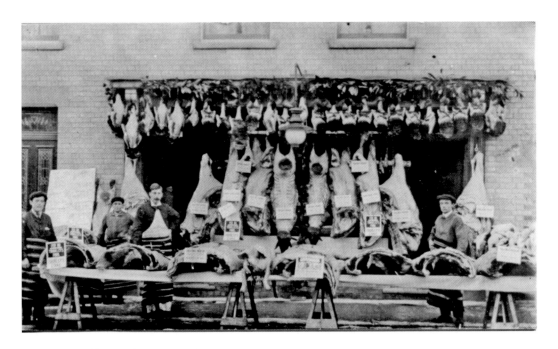

Leonard's Butchers c. 1906

In 1906 the George and Dragon pub was demolished and Edward Leonard built a new butcher's shop with living accommodation over it. Mr Leonard stands in the doorway with what is probably a Christmas display of meat. The shop front has a splendid gas globe, much appreciated by customers as shops stayed open late. It is still a butcher's shop and has just re-opened. It is owned by Roger Webster Ward, on the left, with Simon Pettit and manager Ron Parkins.

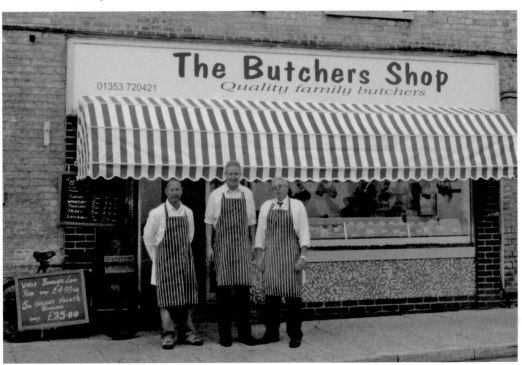

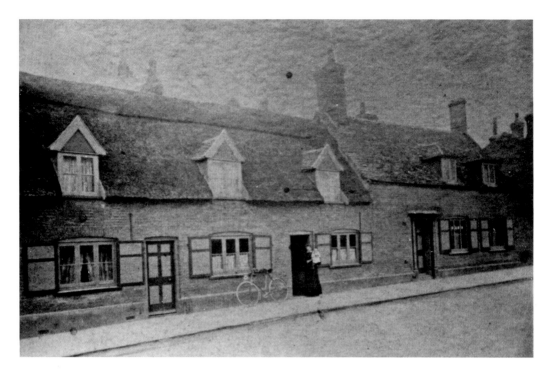

The Red Lion, 1909

The ancient inn the Red Lion in the High Street, on the corner of Red Lion Square. When this photograph was taken in about 1909, the Martin family held the licence, and Mrs Martin is holding Josh Junior. The Martin family were well known as horse dealers and slaughterers. Josh Martin is seen below at 90 with granddaughter Emily. Josh Martin is 100 this year.

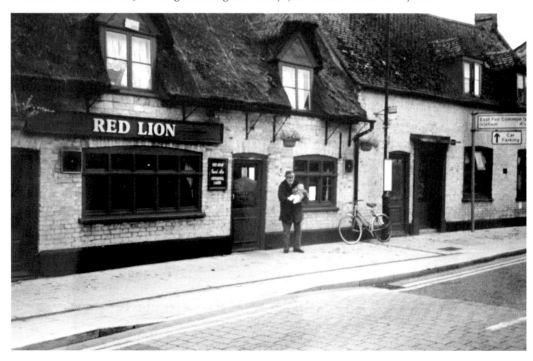

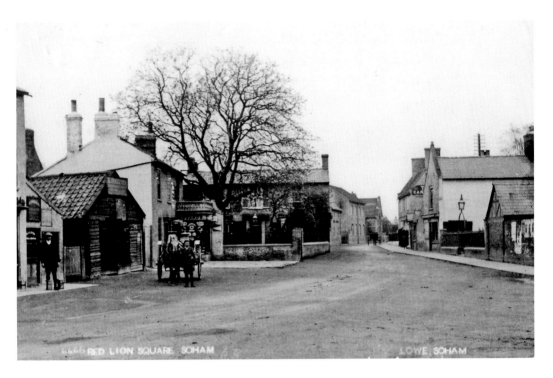

Red Lion Square c. 1910

Red Lion Square before the war memorial was erected. The large house that can be seen endways onto the street was demolished in 1938. It had been in the Martin family until Julia Martin's death in 1927. The house was demolished to provide a site for the Regent Cinema which opened in 1939. The cart, with its churns for delivering milk, stands in front of Edwards' grocery shop. The modern photo shows the new monument to the heroes of the 1944 train explosion.

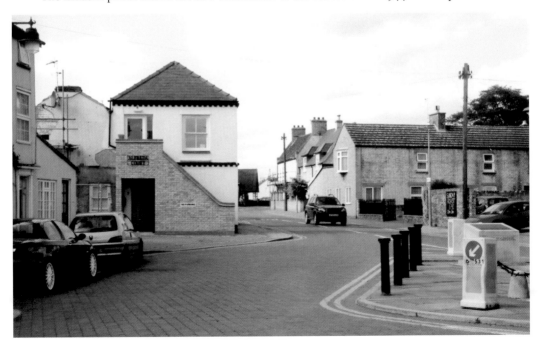

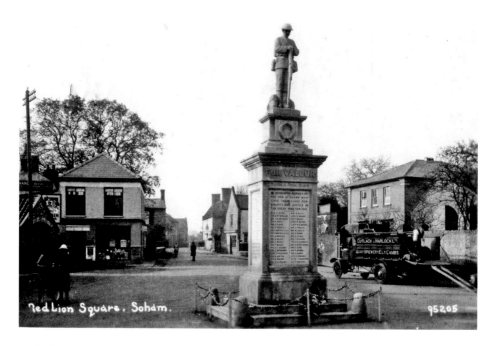

Red Lion Square in the 1920s

Red Lion Square with the war memorial built in 1921. Bowman's Stores has succeeded Edwards in a new building that nearly obscures the Martins' house. This building later became the Rendezvous Club, which was one of Soham's social centres after the Second World War. The modern view shows the old Rendezvous being redeveloped into Alfreda Court, a block of flats, and across the road is Saucy Megabytes, a cyber café linked to the Red Lion public house.

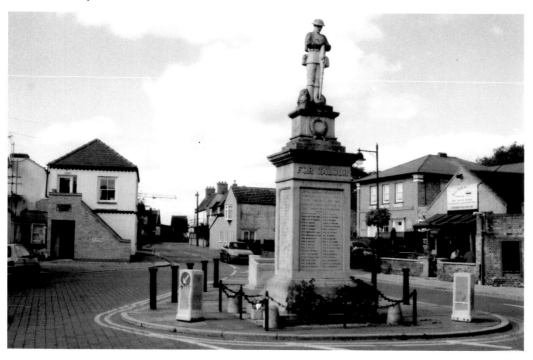

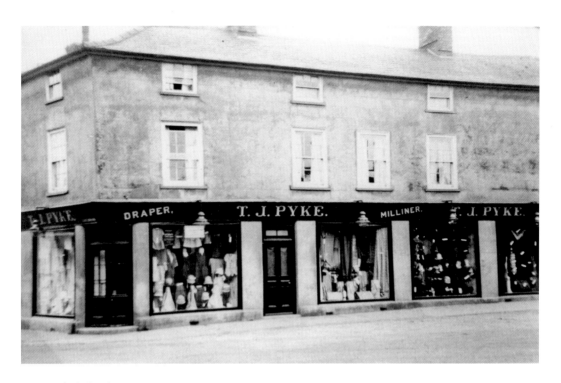

Pyke's in the 1930s

Draper and milliner T. J. Pyke occupied a prominent place alongside Red Lion Square. The shop was there in the 1930s. Later, under the Clements family, it became the Milkiway Café, famous for its Milkiway ice creams, which were a real treat in the 1950s. The present fashion for fast food is seen in today's photo alongside the O Porto Café catering for locals and the many Portuguese workers settled over here.

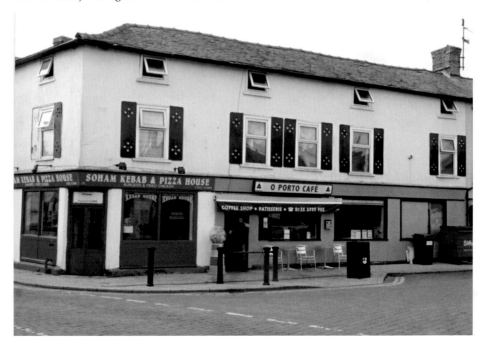

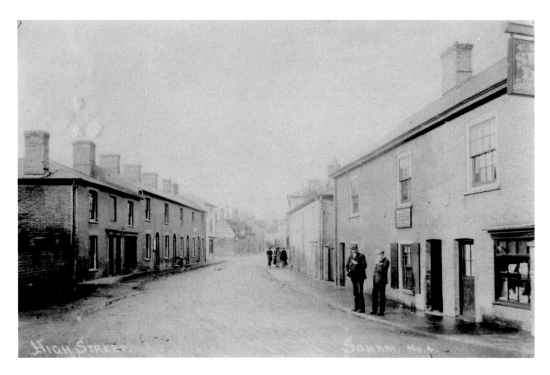

The Ship Inn

The Ship Inn on High Street near the bridge over the Soham Lode photographed in about 1908 when Walter George Cross was the landlord. The shop front incorporated into the pub has now gone and alongside it today there is car display space for Crown Garage, which is opposite. Josh Schunmann, the licensee of the Ship, stands outside his pub, which is one of only five in Soham today.

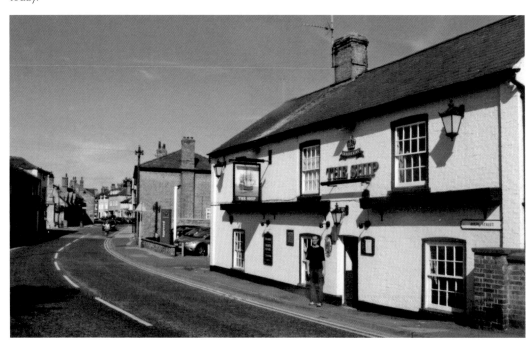

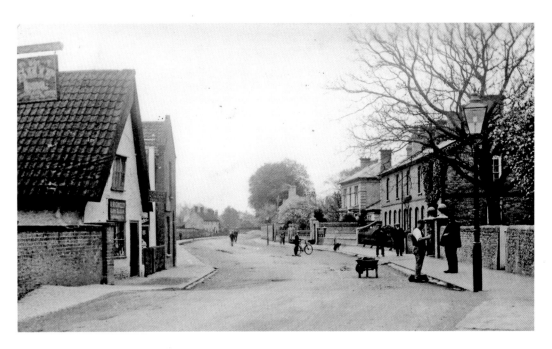

Sand Street

Standing on the Stone Bridge over the river, the sign of the Ship can be seen but not the pub. The shop next to the bridge is A. R. Covell's Fancy Bazaar and Confectioners, with a sign that says 'Cyclists rest, teas, etc'. The gateposts on the right are at the head of a driveway leading down to The Moat, while the terrace of houses are Moat Cottages, dated 1869. The cottages and the imposing house of the Ennion family along Sand Street have altered little over the years.

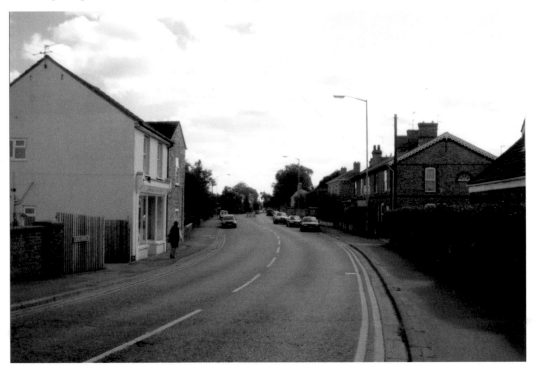

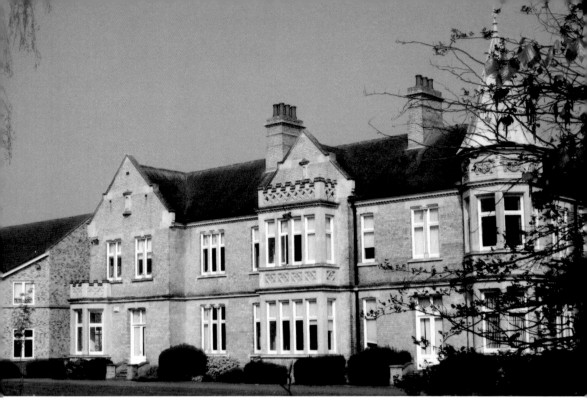

Beechurst

Beechurst on Sand Street was built for the Morbey family in 1900. It was the grandest residence in Soham and the Morbeys moved from the Moat to occupy it. In 1925, changing family fortunes saw the Morbeys move into Addison House on Sand Street and this house becoming Soham Grammar School. In 1971 the grammar school joined with the village college that had been built in 1958 on the Moat fields to become a new comprehensive school. The Gibson Wing, built in 1996, can be seen on today's photograph.

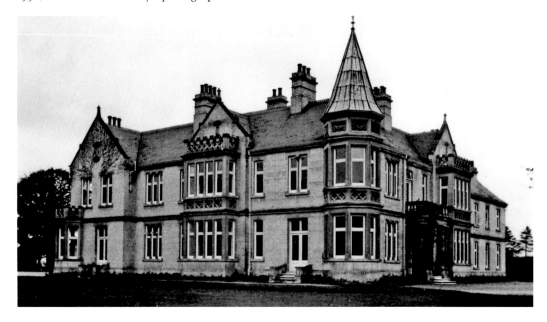

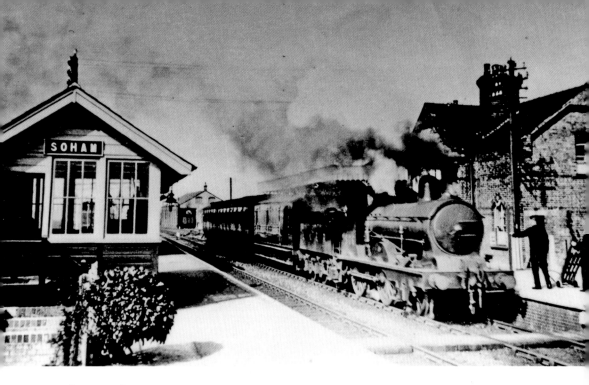

Soham Station 1939

Soham Station, pictured here in 1939, was destroyed by the 1944 wartime explosion of a truck laden with bombs. Fireman James Nightall was killed, signalman Frank 'Sailor' Bridges died of his injuries, while Benjamin Gimbert, the driver, was seriously injured. Driver and fireman were awarded the George Cross. The station re-opened with temporary buildings, but fell to the Beeching axe in the 1960s although trains still pass through on the line.

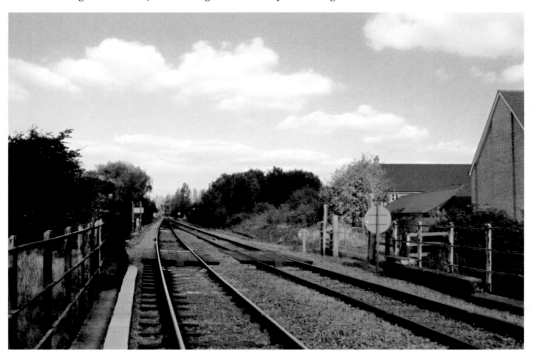

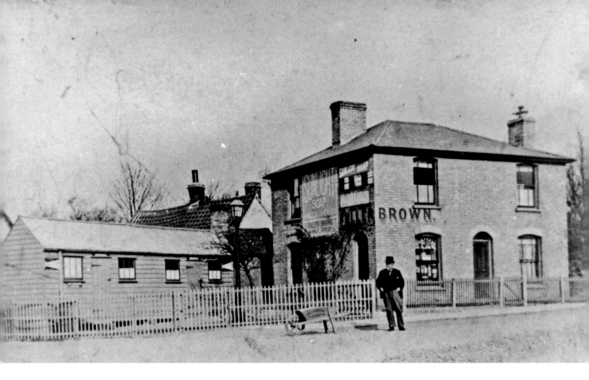

Fuller Brown's

Mr Fuller Brown outside his grocery shop on the corner of Station Road and the Piece. This view was probably taken before 1900, when he was able to benefit from the passengers going to and from the railway station. The business went to Leonard Rayner for a short while and from him to Horace Taylor. The Taylor family continued the business until the 1950s when the premises were converted to a private house. Today, Mrs Botting stands at the gate of her home.

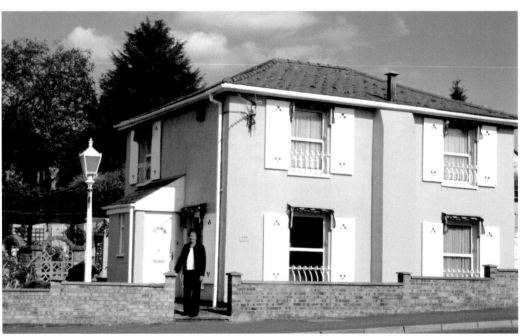

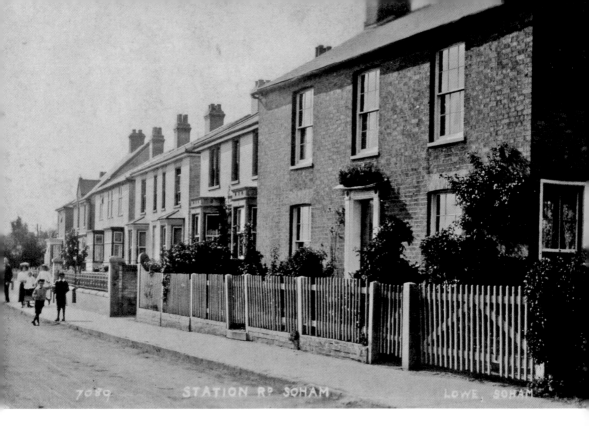

Station Road

The coming of the railway in 1879 brought new prosperity and growth to Soham. Pump Lane, once Thompson's Lane, was renamed Station Road. This fine row of villas were all built in the latter part of the nineteenth century. The house in the foreground was demolished in the early 1960s to enable a new entrance to be made for the West Drive Gardens development.

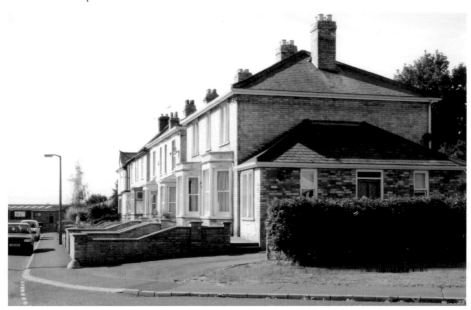

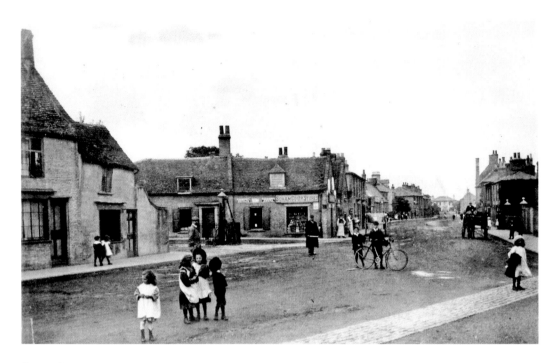

Cross Green

Cross Green in about 1910. At the junction of Churchgate Street, Pratt Street and Station Road, this was a focal point of Soham. Here stood the town pump, which can be seen with the Co-op behind it. Until the piped water supply came in 1923, many people drew their water from the various pumps and they were popular meeting places. This pump had two spouts, one for ordinary use and a higher one for water carts.

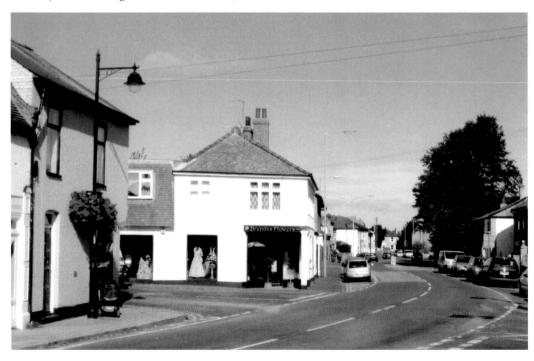

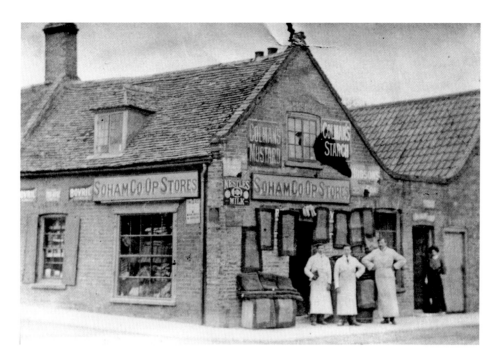

Soham Co-op c. 1906

Soham Co-op later became Parish's butchers. The old shop was demolished and a new shop was built for Mrs Fuller's woolshop and Mr Fuller's barbershop. In 1972, it was altered and extended to become a chemist's shop when a new health centre was opened nearly opposite. Since 1998, the premises have been Brenda's Flowers, and Brenda Jugg, the owner, and her assistant Amanda Dewey stand outside.

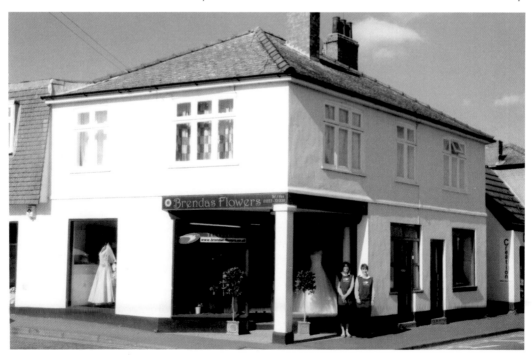

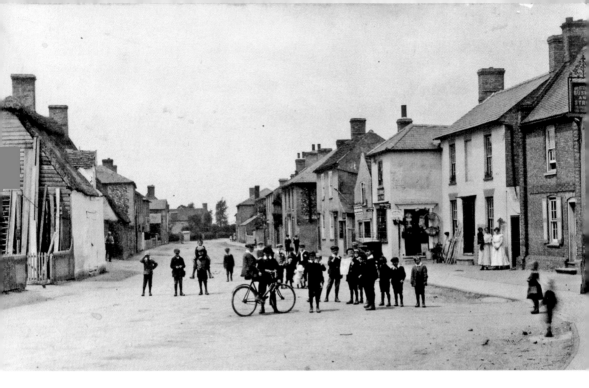

Hall Street

Hall Street, with the Bushel and Strike in the right foreground. Opposite is George Shaw's carpenters, later Fuller and Johnson's and now C. E. Fuller and Co. In the early 1900s it was a busy street with four blacksmiths, three carpenters and two other public houses. Munn's ironmongers and Elsden's hairdressers can be seen in the right foreground. Today, apart from C. E. Fuller's, now a funeral directors, and the corner shop at the bottom, the street is residential.

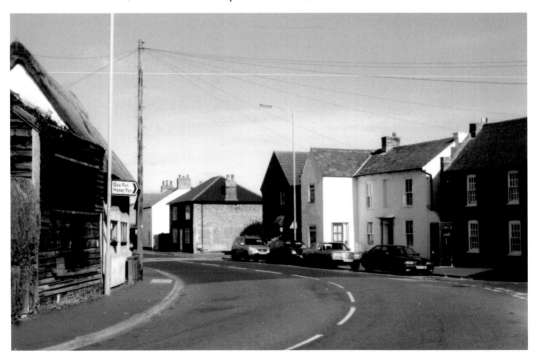

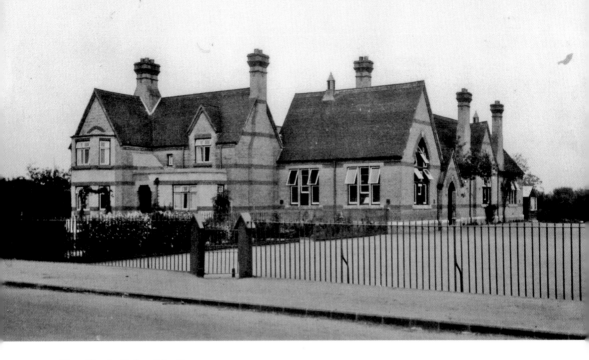

The Shade School in the 1930s

The Shade School was opened in 1875 as the Soham Board Boys School. In 1906 the name was changed to Soham Boys and Infants County School. The first head was Joseph Farrow, followed in 1906 by Mr G. F. Fenton and in 1926 Mr P. W. (Pop) Lovering, M.C., MBE. In 1958 the Village College was opened and the school became the Soham County Junior Mixed School. The school closed in 1990 with pupils transferring to the Weatheralls. All that can be seen today is the old school house.

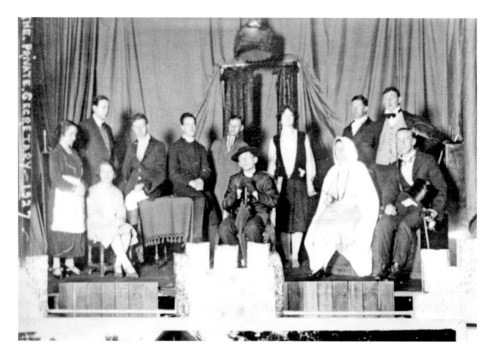

'Treading the boards'

'Pop' Lovering formed a dramatic society and in 1927 they performed *The Private Secretary* in the Conservative Club. In the cast were Cecil Crouch, Dennis Peat, Cecil Ford, Stanley Thompson, Cynthia Goodin, Florrie Rouse, May Rouse and Dorothy Mann. In 1997, Viva Youth Theatre was formed and now Daniel Schumann's company perform at least three musicals a year, one of which goes to the Edinburgh Fringe, and since 2007 there has been an adult group. Hundreds of young people performed with Viva. This is the cast of *Gypsy* in 2009.

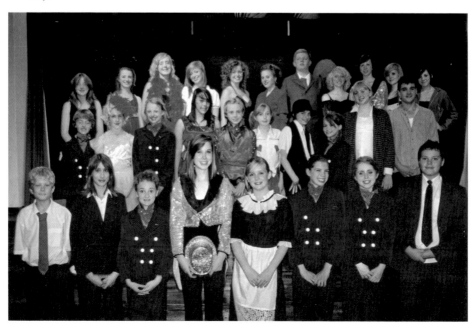

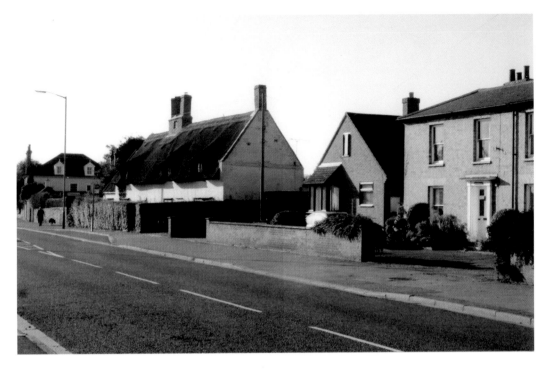

Townsend

A view of Townsend opposite where the old Shade School stood. The thatched cottages have the date 1687 on the chimney stack and were once the Hoops public house. In the distance can be seen the rear of Melton House, once the home of Josh Martin, who was a licensed horse slaughterer and dealer. His business card promised 'Old favourites slaughtered upon owners' premises by experienced men'. Apart from some modern infill, the view has changed very little.

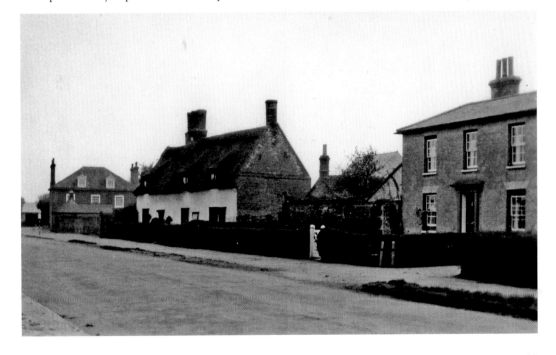

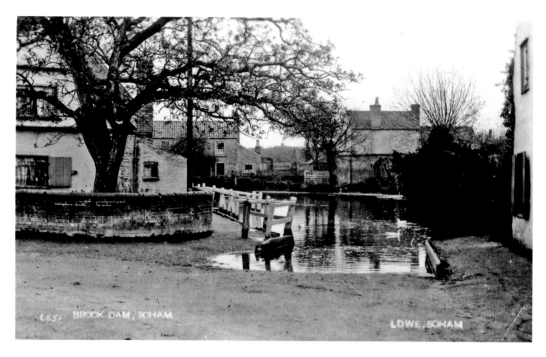

Brook Dam

Brook Dam in the early years of the last century, showing where the horses could enter the river to drink. A simple turnstile restricted the path alongside it to pedestrians and there are steps for those who wanted to draw water from the river. Here the river, coming from East Fen Common, turns behind Red Lion Square before going under the main road at Sand Street. Today, it has a low wall, a promenade with seats and is very popular with children for feeding the ducks.

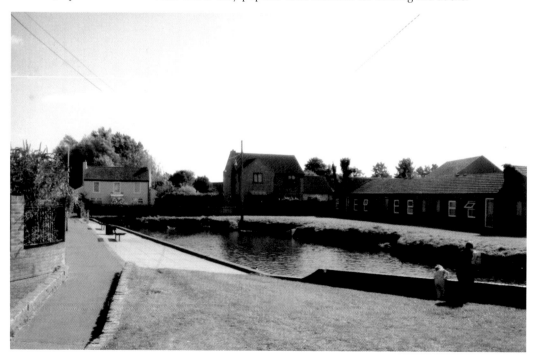

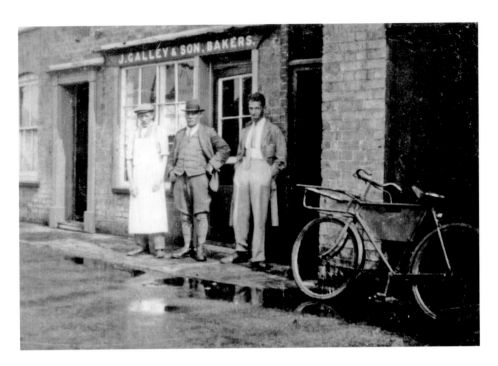

Galley and Son

J. Galley and Son, bakers, stood at the bottom of Paddock Street at the entrance to East Fen Common. Jim Galley stands on the left with Tyrell Galley his son on the right in this 1920s photograph. The business finished soon after the Second World War. The building, which dates from 1863, had been the Bush public house. It was said that at weekends, 'the beer ran out of the door'. It had a reputation for fighting and brawling.

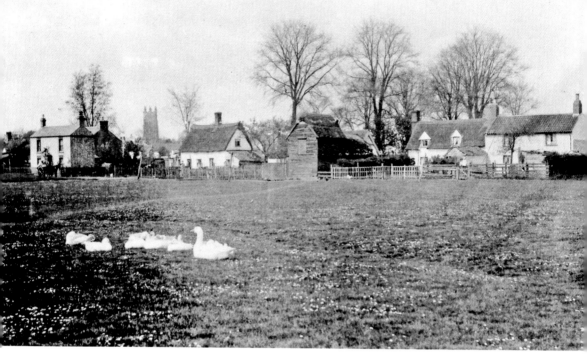

East Fen Common

East Fen Common in the early twentieth century. The Bush pub was their local. It is difficult to imagine from this idyllic scene of one of Soham's commons, that East Fen Common had a reputation for its roughness. Its reputation was such that when the road was opened up through the common to Isleham, the people of that village still preferred to take the long way round rather than cross the Common.

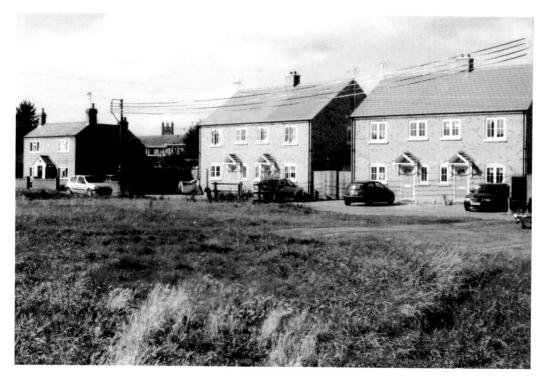

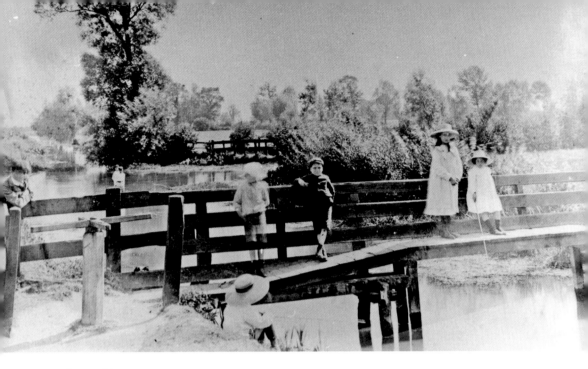

Loftus Bridge

The River Snail flows through East Fen Common. Loftus Bridge was a popular meeting place carrying the ancient footpaths across the river. Cottagers living nearby would draw water from the river, wash and paddle in it. Cattle would drink from it. It is still a beautiful spot, as my daughters discovered. There are cattle and horses on the Common and a delightful walk along the riverbank into Soham.

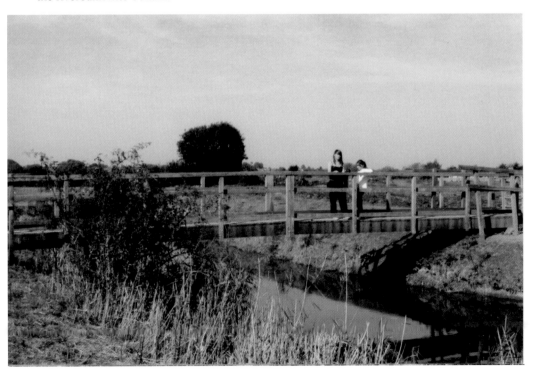

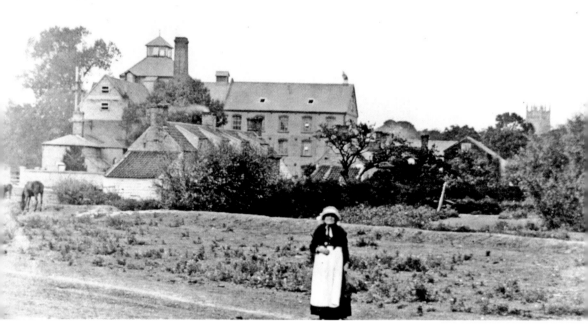

The Mill

The River Snail flows through Soham, eventually becoming known as the Soham Lode. On the far side of Soham the river runs into the old mill pond, before taking a distinctly man-made route down to the Ouse. Clark and Butcher's mill stood at this point. Alfred Clark bought the watermill in 1864. In 1870 he was joined by Herbert Butcher. The mill was able to use barges to send flour to Ely. The old mill, seen here from Angle Common, was destroyed by fire in 1945.

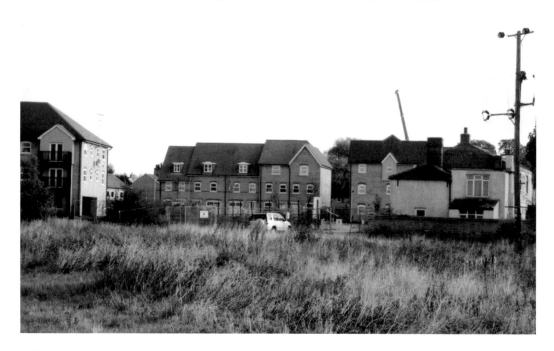

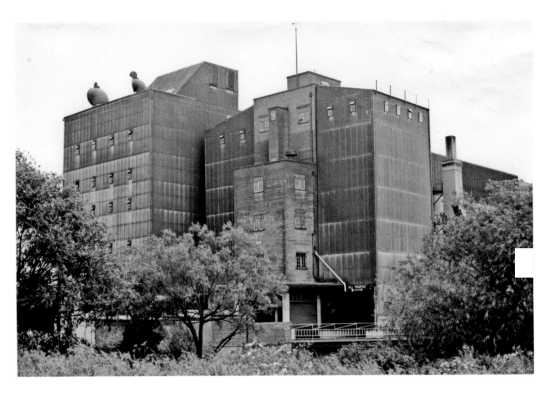

Lion Mill

The mill was rebuilt as Lion Mill. Photographed here by me in around 1970, it was a functional building but a major employer in Soham. The Clark family ran the mill until it ceased production and the whole site was sold for housing. It is now being redeveloped with modern houses overlooking the old mill pond.

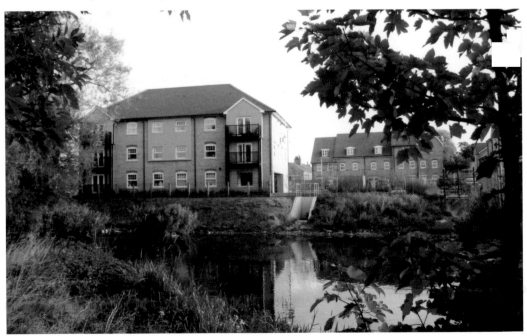

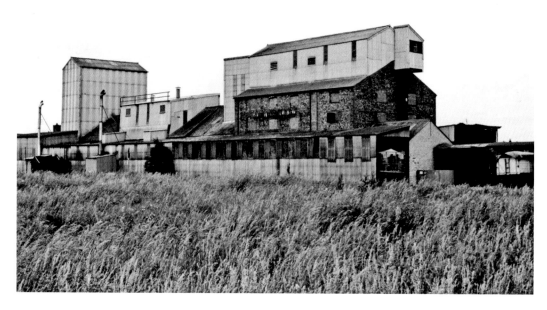

The Flint

The old granary of Clark and Butcher's mill was known as the 'flint'. Flint stones are embedded in its walls. It had originally been a maltings but was gutted in the late 1920s, and wheat silos were installed. It stands right alongside the Lode. With all the added steel works and cladding removed in recent years, it has all been converted into riverside houses and apartments.

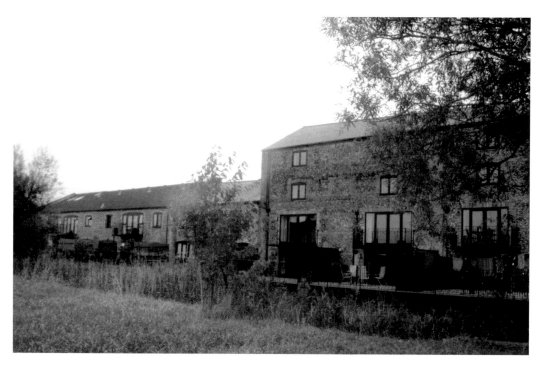

Downfields Mill 1925

Soham stands on a ridge of higher land carrying the road from Newmarket to Ely. At one time there was a line of five corn mills from one end of Soham to the other. The Shade windmill survives, but this is the other survivor, Downfields Mill. Built as a smock mill in the 1720s, it was rebuilt as a tower mill in 1890. Rex Wailes photographed it here in 1925. Today it is surrounded by housing and, after some years working with two sails, now looks in dire need of restoration.

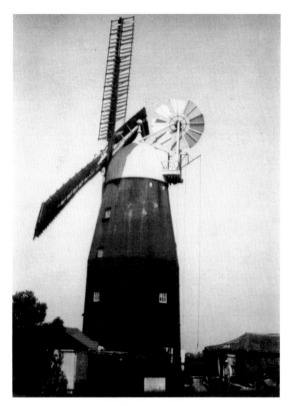

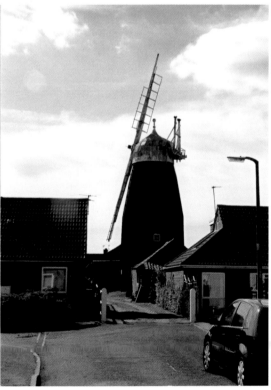

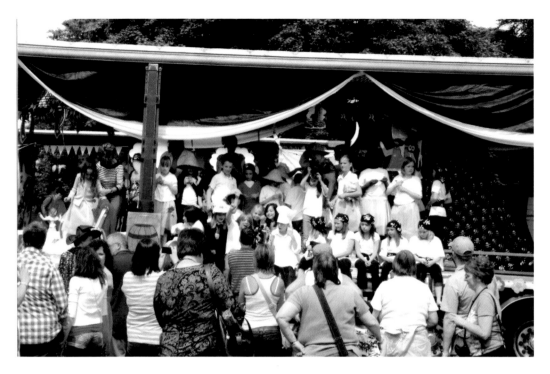

The Parade

The famous Soham parade marked the start of the Soham Feast celebrations in June, and filled the streets with people. Floats were a popular part of the parade and the famous Soham Comrades Band was always a feature. The tradition continues today, though few today would know what a 'Slate Club' was. The Carnival and Heavy Horse Show on Spring Bank Holiday stills draws a few floats based mainly on the rivalry between the Weatheralls school and St Andrew's. In 2009, the St Andrew's float carried off the cup.

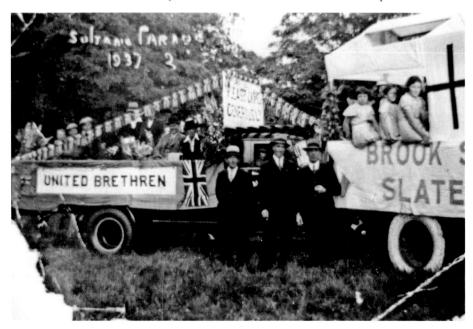

Wicken

Lode Lane

The route to the fen from the main road is Lode Lane where, at the bottom, the lode begins. Years back this was a busy scene of turf men and dealers, sedge and reed harvesters and a few fishermen, where lived eleven families at one time in homes insulated with turves and thatched with reeds and sedge. They were demolished one after the other until the National Trust decided to maintain the cottage on the right as a showpiece open to the public.

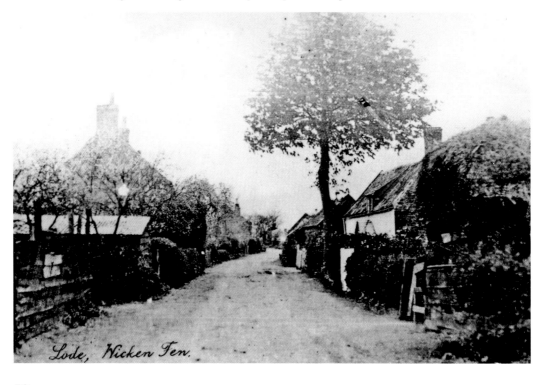

Lode, Wicken Fen.

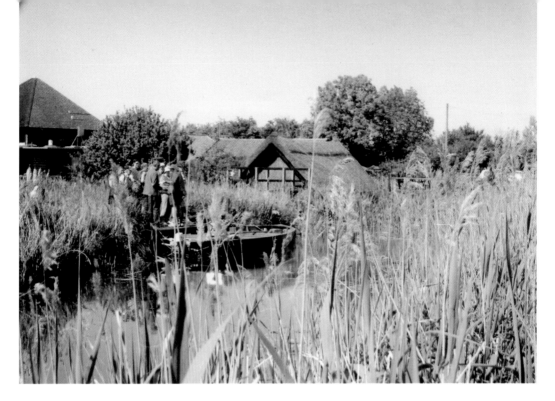

Wicken Lode

Leisure is truly the theme in these views at the mouth of Wicken Lode. Inevitably, the early photographer, Emma Aspland, has captured her subjects on a Sunday when leisure was everybody's, the dress neat and tidy. Today's view catches a group about to embark on a lode trip to Upware and back, the day fine, the water placid.

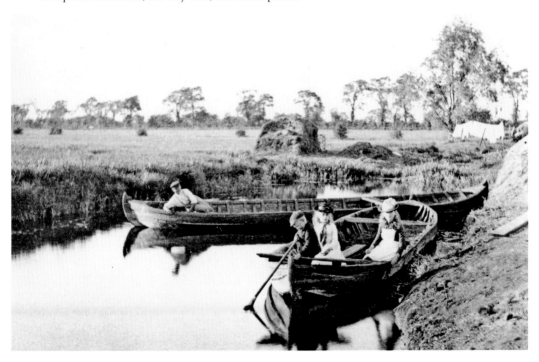

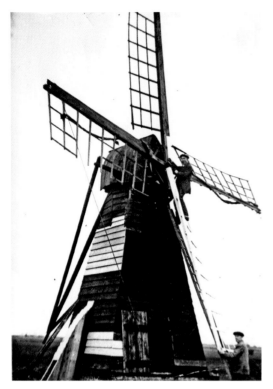

Windmill

Decades on, after the great seventeenth-century drainage scheme, it became evident that the peat was eroding under the plough, and mills would be needed to lift the water into the rivers to prevent flooding. The first mills were horsedrawn, then wooden windmills were erected and these lasted well into the twentieth century. Such were used to drain turf-pits, the one shown being the last to survive, which became the model for the showpiece today. It is here shown having its canvases fitted for a demonstration of its function.

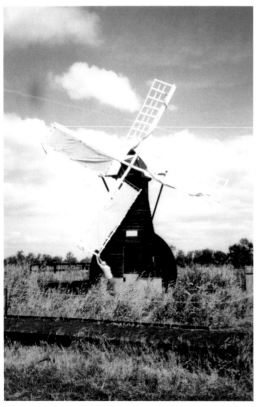

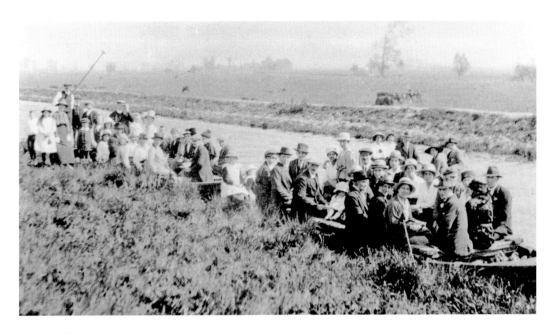

Sedge Boats

In the twentieth century, the rivers and lodes of the fens were much used for leisure. Sedge boats are in use here in 1923 for an outing arranged by the Wicken vicar of that time for his former flock from Luton. Bill Barnes, the first Wicken fen keeper, arranged many a holiday trip in this way, and is seen here holding the bargepole. Today's arranged trips are quieter and smaller, with safety the first priority.

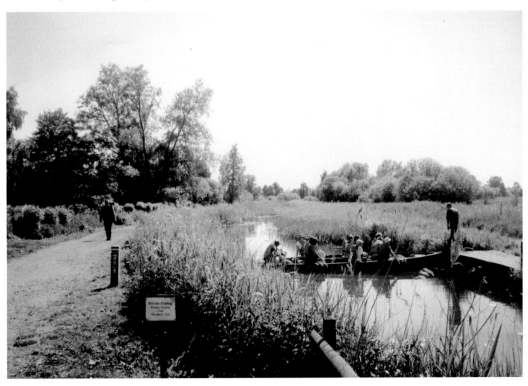

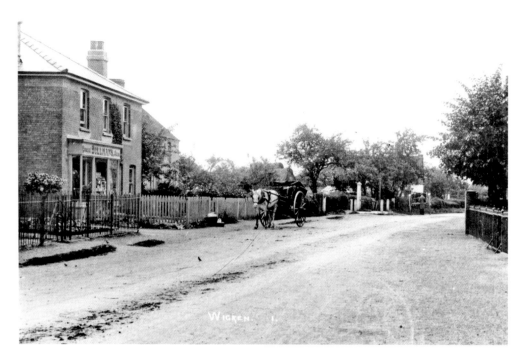

Wickan's Last Post Office

The shop on the left in North Street was, at this time of 1915, owned by Arthur Bullman, who was prominent in local life. The shop had caught fire three years earlier and the restoration shows under the eaves. It went through many hands until 1993 when it closed down, the premises now holding a thriving business. It had been Wicken's last post office, as the remaining pillarbox indicates.

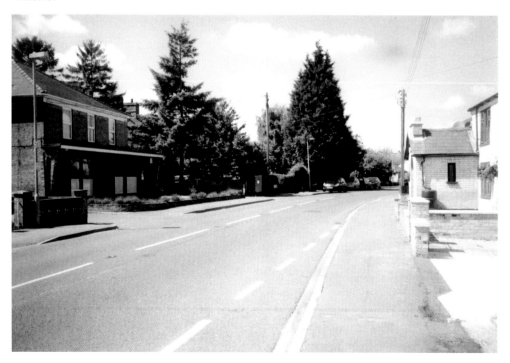

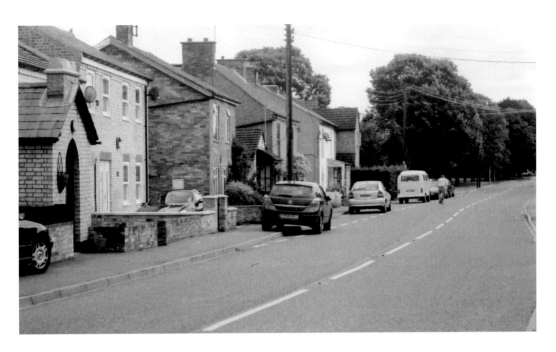

North Street Looking East

North Street looking east in the late 1940s, beyond the car the small workshop built for Peachey Johnson, cobbler, was later converted into a small tobacco and confectionery shop for Ellis Leonard. After his occupation it was removed. The newly-planted trees beyond are now in full height and leaf.

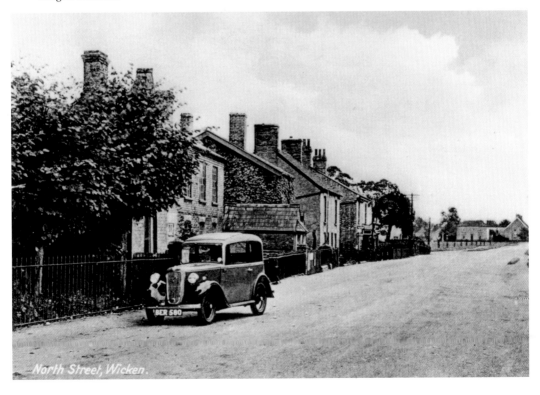

North Street, Wicken.

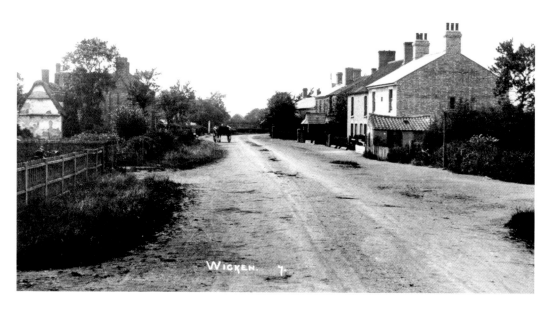

North Street looking West

Looking west along North Street *c.* 1910. The demolition shows only on the left with the loss, by fire in 1913, of another thatched dwelling. The strewn road betrays mainly horse traffic at this time. The turn to the left is into the blacksmith's yard. Today's view shows little more than ordered updating and the problem of parking where there is no space on the premises.

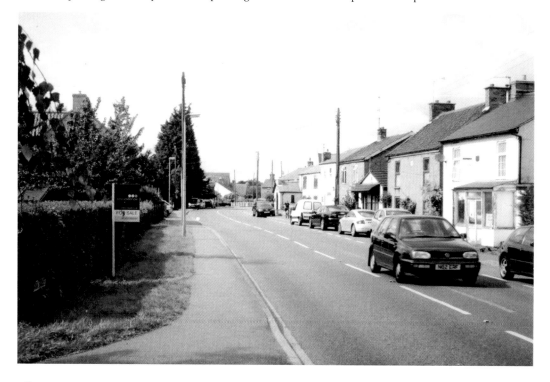

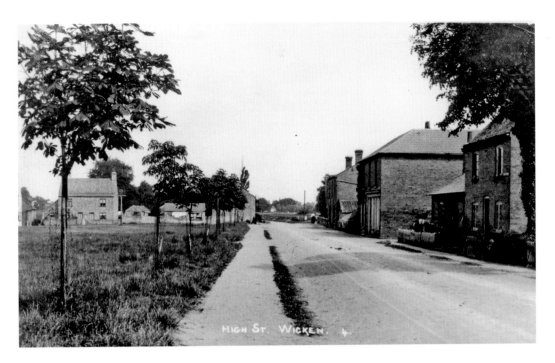

High Street looking East

High Street looking east shows the horse chestnut trees planted in 1908. The largest house on the right was the mill house by the entrance to the mill. Those trees today are giving in to old age, a few having been removed already. The bungalow to the right of the mill house has recently been incorporated into the large white house. With the necessary road widening, the footpath is now on the inside of the trees.

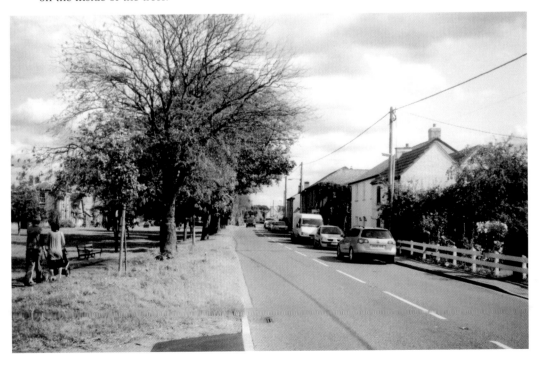

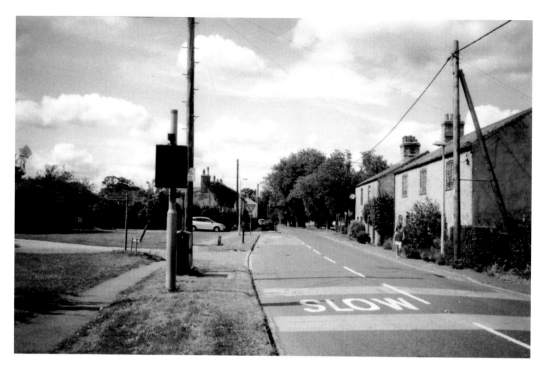

Cross Green

We live in a manicured age of mown grass and edged paths and roads and concessions to fast, heavy traffic. Once the greens were grazing places where children played while being careful where they trod. Soon came the first telegraph pole with one line for a few years and today's pole at Cross Green is in the original place. This is looking west along High Street.

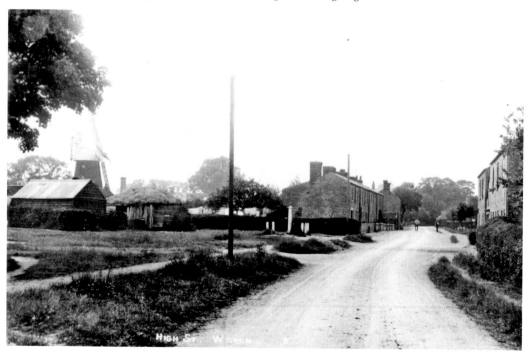

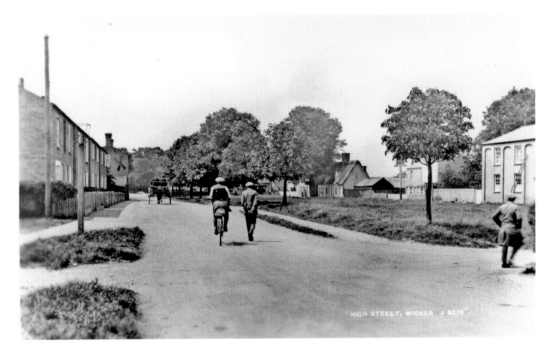

High Street looking West

High Street looking west with the Maid's Head green on the right in the 1920s, the cyclist keeping pace with the walker with no threat from behind or in front in those traffic-free times. Today, the figure rests on the seat by the bus stop as if that peace still reigns, but within seconds his silence would have been interrupted by cars and lorries using the route as a 'rat-run' to the A10 beyond. The Maid's Head clubroom — today a restaurant — shows on the right in each location.

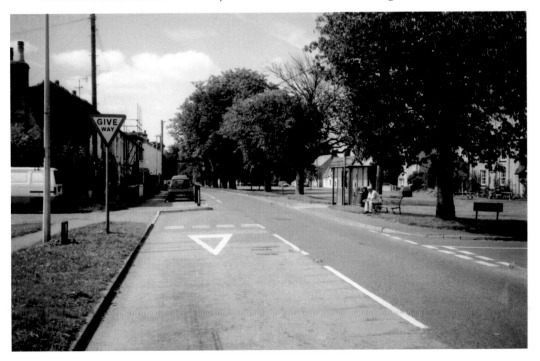

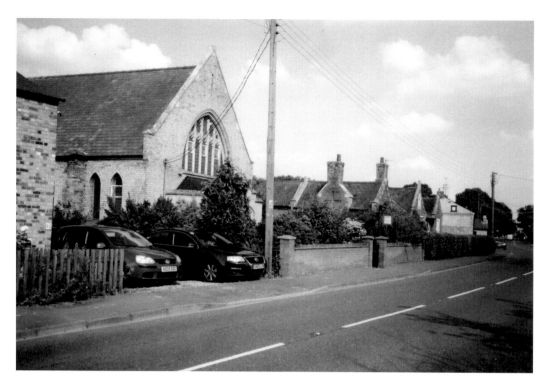

Wesleyan Chapel

The first Wesleyan chapel in the village was built in the 1820s, later to be extended before being demolished in 1910 and replaced in 1911. It stands in North Street next to Mary Hatch almshouses, there since the 1850s. These have been updated inside while retaining their original external character. The fine railings in the front of the chapel were sacrificed to the war effort in 1940.

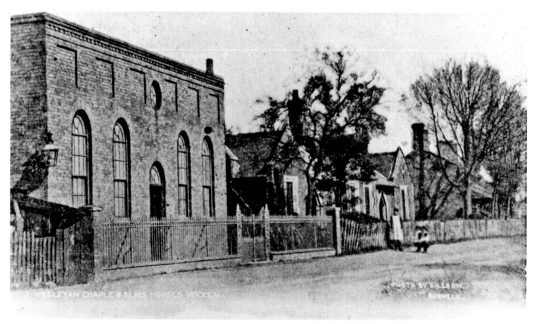

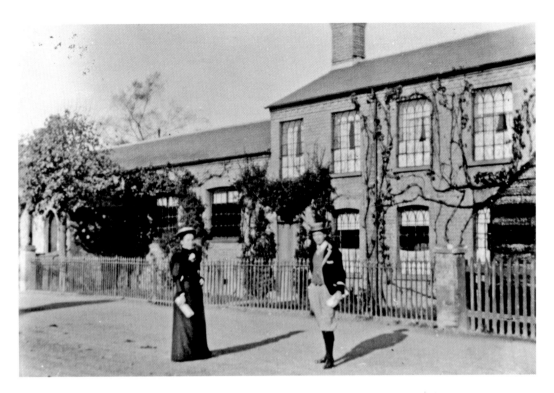

Wicken School

Sarah Rayner, the recently widowed Lady of the Manor of Wicken, provided the first school for the village in 1831. The lady died before the building was completed but her sister, Mary Hatch, to whom she had left most of her estate, saw it through to completion as seen in Emma Aspland's picture *c.* 1900. Today it consists of three separate homes, the main part renovated recently to its great advantage. The school served until 1908.

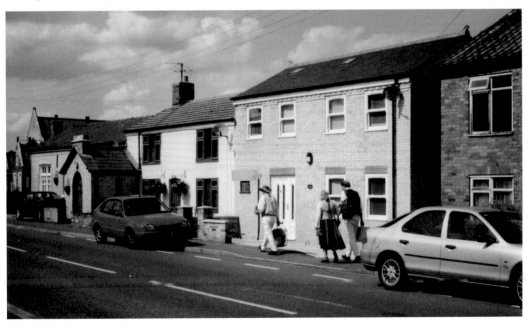

Wicken School *Continued*

The arrival in 1906 of Percy John Walling as headmaster, following a succession of headmistresses, transformed education within the village. His immediate intent was to secure the building of a new school at the north end of the village. This survived until 1992 and today the building has been converted into three separate homes. It was a sad day indeed when it closed.

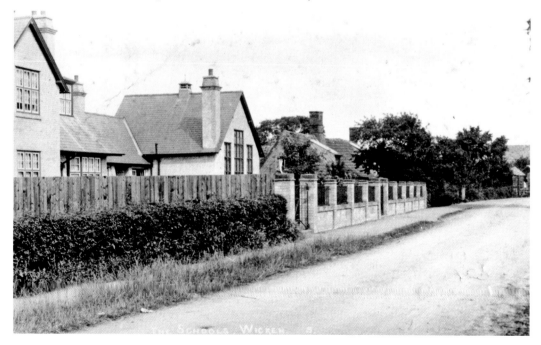

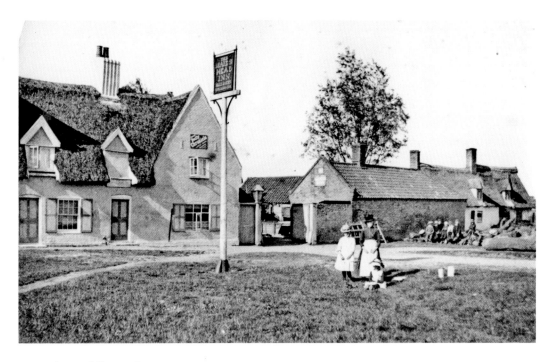

The Maid's Head

One of Wicken's two pubs, the Maid's Head, dates from 1579. This view from 1892 also shows the timber yard adjacent, extending onto the village green. The property looks little changed today but in 1983 the pub caught fire and had to be demolished, but only to be replaced by a replica. The reduced outbuilding is now a hairdressing salon. *Inset:* the pub on fire.

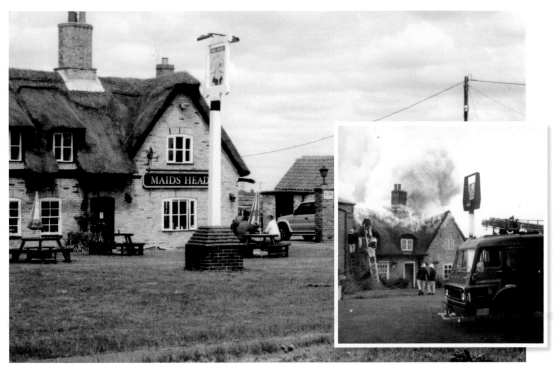

The Lord Nelson

The hamlet of Upware within the parish of Wicken was famed for its riverside inn, The Lord Nelson, dating from 1811. It became better known as 'The Five Miles from Anywhere — No Hurry', thus dubbed by a bohemian character, Richard Ramsey Fielder, 'The King of Upware' by his own definition. The inn caught fire in 1955 and much later was replaced by the present inn carrying the same name.

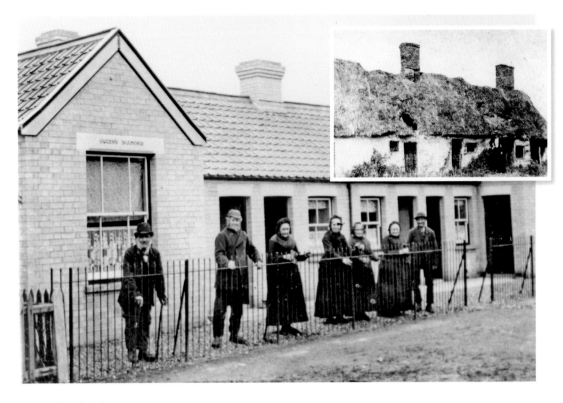

The Almshouses

The Priory of Saint Mary and the Holy Cross was founded in Wicken in 1228 and was inherited by Mary de Bassingbourn who extended it. In 1321, that lady provided a hospice for seven poor and infirm old men of the parish and it stood until the 1890s and was then replaced by six units under one roof to commemorate Queen Victoria's diamond jubilee in 1897. These in turn were replaced by three modern units in 1992. The occupants then and now show their appreciation. *Inset*: the old hospice.

Wicken Celebrations

Villages had their Feast Days from way back in time, bringing families together as at Christmas. Wicken's was on 13 May and by 1900 travelling fairs attended, the roundabout driven by a pony. Until the Second World War, these fairs grew bigger and more modern but no longer visit Wicken. Today the village has its annual fête, the profits shared locally.

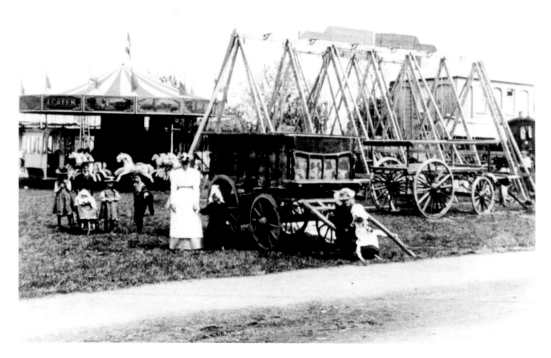

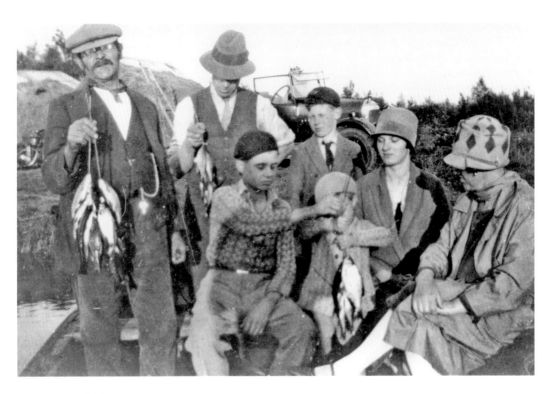

Gone Fishing!

The ancient tradition of feeding off the fen and its waters was slow to give way in the village. Undoubtedly, old Uriah Marshall (left) was the instigator for an hour's fishing with nets in the 1920s, a method banned soon after. Uriah lived off the wild. Rod and line is the norm today and it is mainly a lad's sport, the well-stocked pond the first attraction.

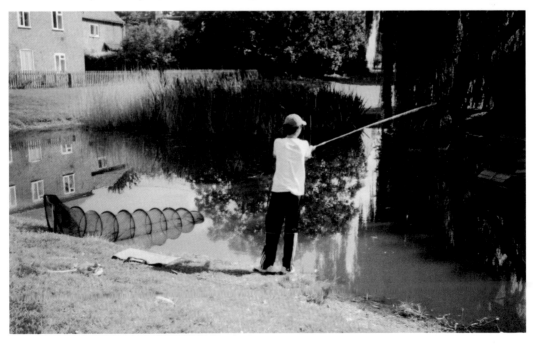

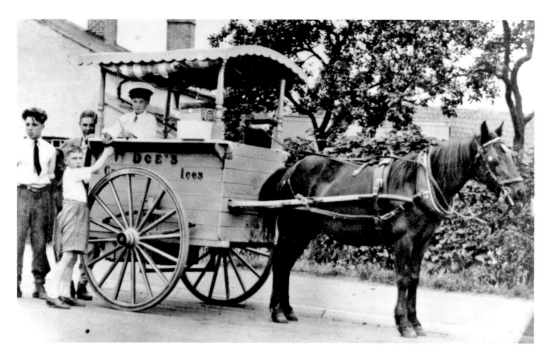

Ice Cream Sellers

He came into the village from Burwell, seven-and-a-half miles by road if but two by footpath across the fen, twice a week in summer, and this purveyor of ambrosial ice cream was Arthur Matey Doe. This in the 1920s and early '30s when he was overtaken by Walls with their tricycle carts and they by 'Creamex' on a motorcycle combination. Matey's son, killed in the Second World War, is in the cart. Today, it is all you can wish for on wheels.

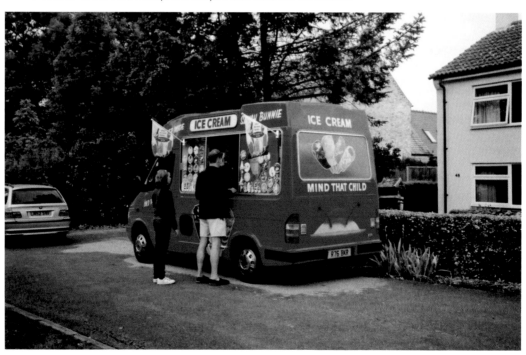

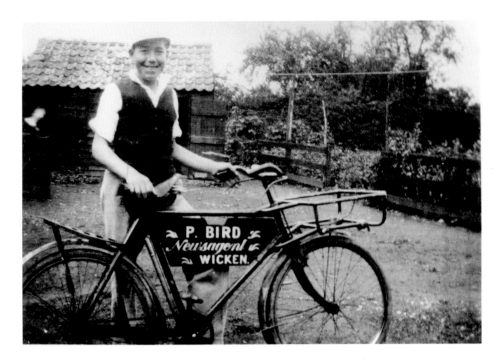

Newspaper Boys

When one of Wicken's four pubs closed down in the 1930s, the building was occupied by Percy Bird who set up as a fruiterer and newsagent. After leaving school, his son, George, fetched the papers daily from Fordham station a good four miles away. It was said he never failed to collect and deliver however bad the weather. Today, the nationals are not delivered but the locals arrive without fail in the hands of schoolboy Dan Strong and his ilk.

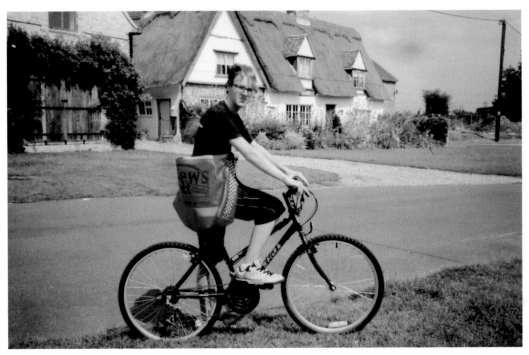

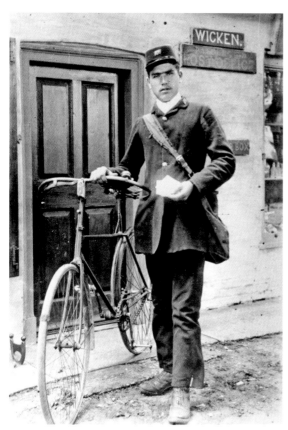

The Village Postie

He is at the door of the post office within the home of Emma Aspland, whose legacy of life around 1900 is so invaluable. Morley Houghton, the postman at that time, had succeeded his father. Albert in the job, after which he succeeded him as a cobbler. You can be sure there is no junk mail in his hand just as you can be sure today's postie, Julie Beaumont, will be unloading it every day on our behalf but always with shining good humour.

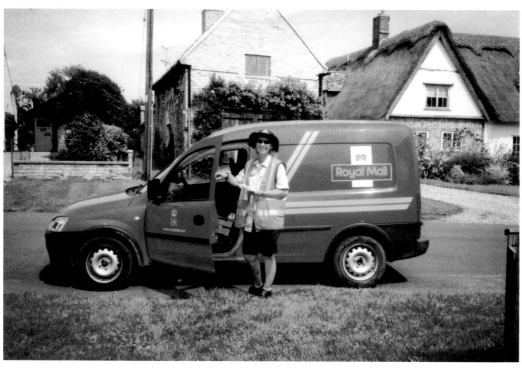

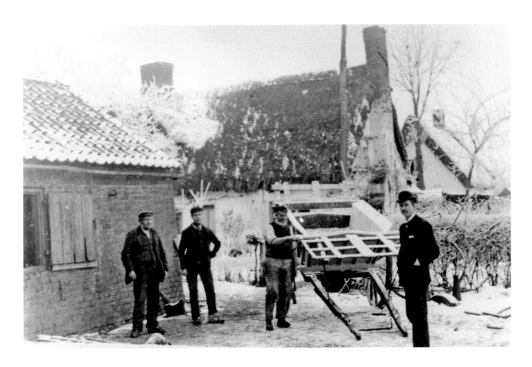

Village Craftsmen

Emma Aspland, *c.* 1900, merely had to go next door to catch William Rose, the retired blacksmith, with his successor, his son Ernie, and his assistant, John Sewell. The other man is Albert Jenkinson, a shopkeeper and lay preacher married to a Wicken woman. Successors at the forge were Arther 'Bill' Redit and his son Walter who sold the house and business to the featured James Garton, who made wrought iron masterpieces until his recent retirement.

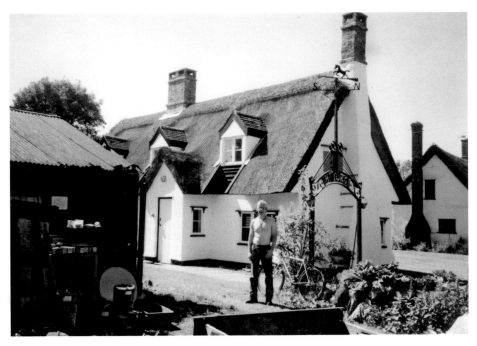

Cross Green Cottage

More than a hundred years apart, these views of a thatched cottage off Cross Green look deceptively similar. Much happened in between the taking of the two photographs. The cottage lived under corrugated iron for several years until it recovered its character in the hands of a dedicated restorer, for which the village is grateful.

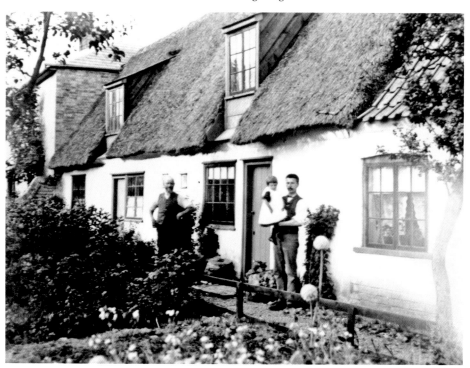

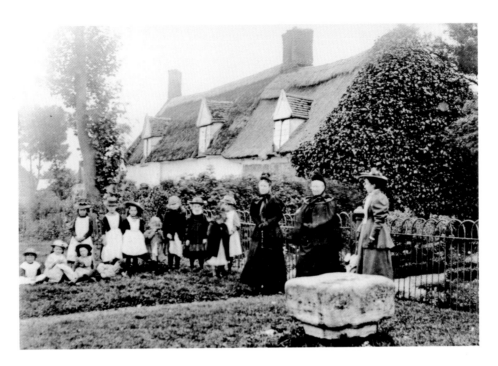

The Market Cross

Emma Aspland has arranged a rare turnout here, including herself, on the right, standing rigidly as if concerned for her replacement photographer. This is Cross Green, the site of the market granted to Hugh de Bassingbourn in 1331. The market cross was upside down, the bulk of it carried away long before, no doubt for hardcore. There were three homes under the one roof behind, and standing are the dignified Mrs Isaac Aspland and Maria Knowles, a Wicken historian. The building came into the hands of Edward Simpkin, butcher, and his son but was restored in the 1990s, before which the cross remains were uprighted.

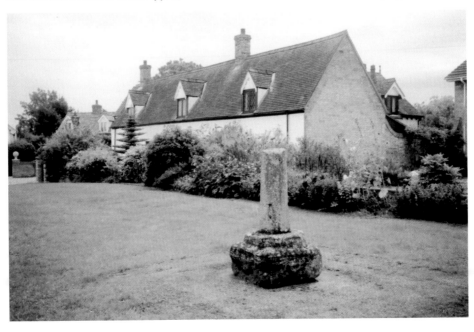

Cross Green

Around 1900 Sidney Cockrill, beer and wine merchant, had possession of this house on Cross Green, both captured by Emma Aspland. The front wall of the house is the original, while the rest was rebuilt in the 1970s, and today it is the home of Colin Searle, standing, and his wife Jan. Colin owns a thriving motor components business.

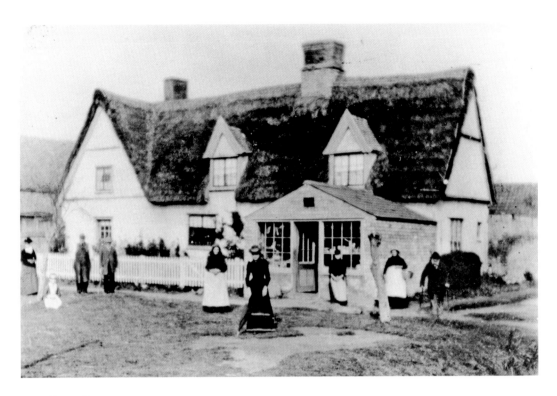

Butts Farm

The Emma Aspland lineup is once more impressive in front of Butts Farm, which ceased to be a farmhouse soon after the Second World War. Eventually, it was restored by an architect who had the frontage removed. A tea importer lived here, succeeded in the business by his widow. Today, further restored, it is a yoga centre.

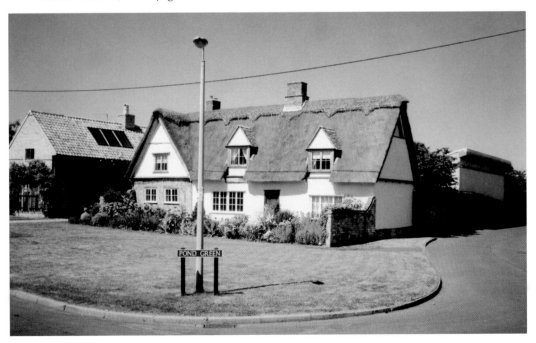

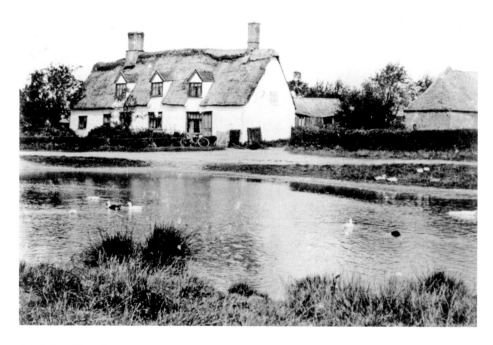

A Wicken Farmhouse

This former farmhouse by the village pond was occupied by James and Ruth Bullman, then by James Day, my great uncle, who farmed from there until the death of his wife in 1930. It was sold to the village shopkeeper from Birmingham, Vincent Towell. He installed Robert Porter who bred pigs on the property, later acquired it and sold it, happily, to a dedicated restorer, Mick Annetts, who occupies it today.

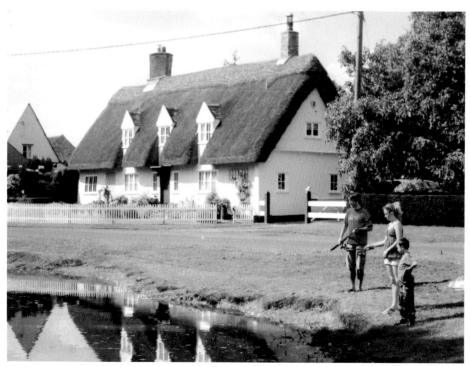

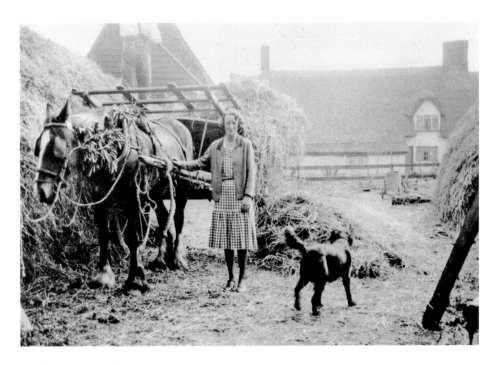

Pond Green Farmhouse

So many of the old houses had farmyards behind them until the smallholders had to concede to the changing times after 1945. Vincent Towell's daughter, Margaret, stands in the newly acquired farmyard, finding it much as James Day left it, this during hay time. The conversion of the yard to a more leisurely space is complete today, its architect standing here at the rear of the Pond Green farmhouse that was.

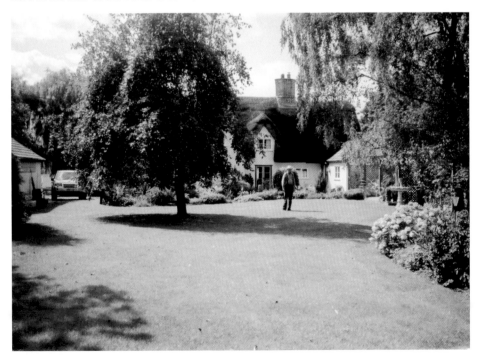

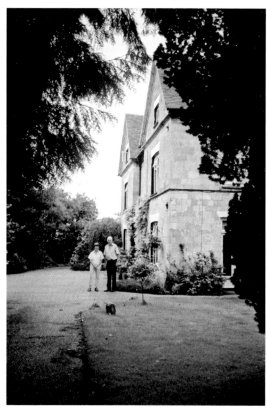

Spinney Abbey

Of Wicken's dwellings this is the grandest. It is Spinney Abbey, thus named for many years although in origin it was a priory founded in 1228. It conceded to the Dissolution of the Monasteries and became a private home for a number of distinguished figures, including Isaac Barrow and Henry Cromwell, the son of the Protector. It was demolished, to be replaced by this fine house in 1775, occupied for the last century by the Fuller family. The present owners are Robert and Valerie Fuller, shown.

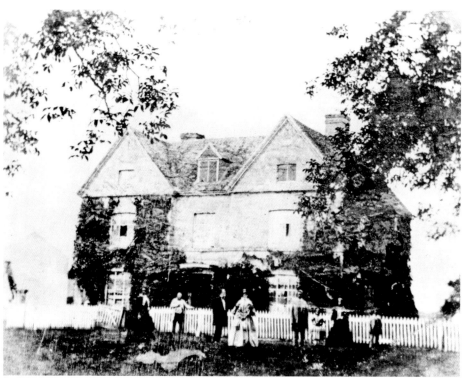

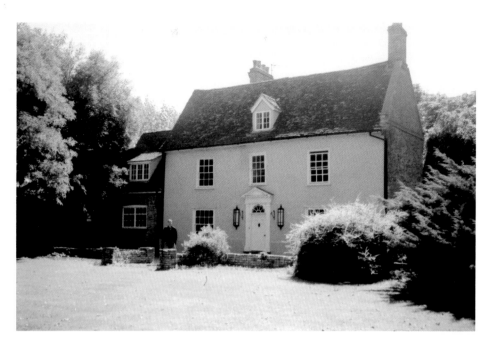

Wicken Hall

About the time that Spinney Abbey was rebuilt, this house, Wicken Hall, was refurbished, one of the homes of the Lord of the Manor. Eventually it was sold to the county council and occupied by successive farmers. Today, it is owned by Mr and Mrs Michael Herbert, whose son, Mark, stands before it in the present view. The building is set behind magnificent trees and the village church.

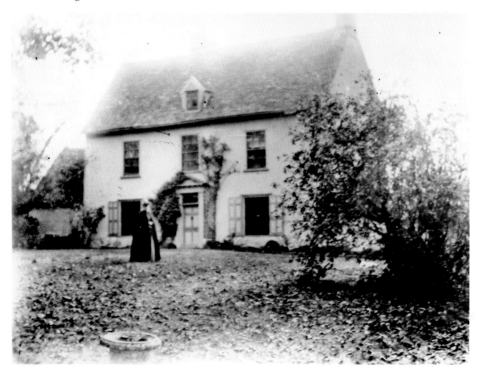

Thorn Hall

The largest farming enterprise of Spinney Abbey included several tied cottages for a large workforce. Thorn Hall off the Lower Road was a cut above the others and was occupied for a long time by the Spinney foreman. After his time it was transformed and extended by Peter Fuller, brother of Robert, into a fine home overlooking Soham Mere. *Below*: the old cottage from behind.

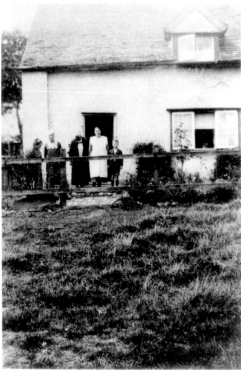

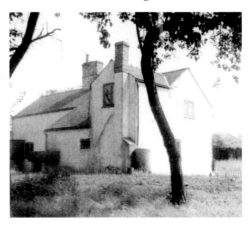

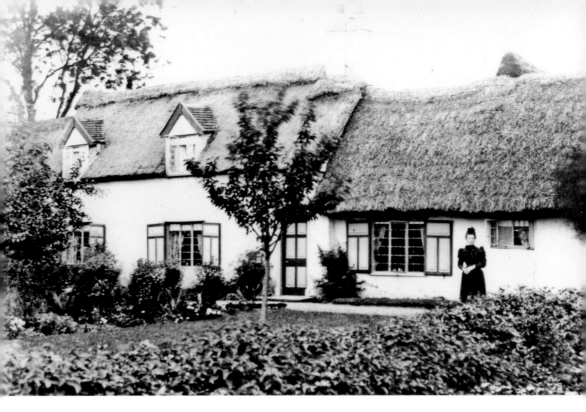

Gray's Farm

Sadly, this farmhouse, seen in a photograph dated *c.* 1905, known as Gray's Farm, was left to sink into the ground after it was vacated when the farm was sold. Farmers Harry and Jack Bailey were the last occupants and their house looked in good shape after the Second World War. Emma Aspland cherished it for our benefit. Some of the outbuildings remain, but the last vestiges of Gray's Farm lie beneath nature's sympathetic covering.

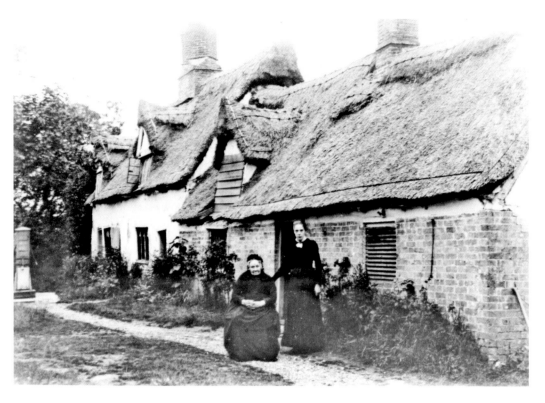

John Hawes' Home

John Hawes' home, seen here with his wife and daughter, vanished but a few years after this picture was taken by the clairvoyant Emma Aspland. My grandfather took over the site, retaining it as orchard and a small pasture. Above the site today is a recent development of eight homes under four roofs by the main road.

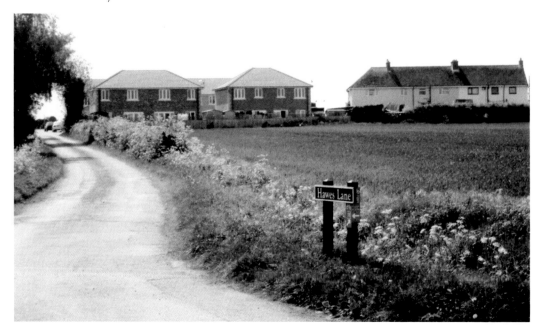

Docking Cottage

Known to us simply as Will and Ann Dorking's home in Chapel Lane, its thatch was sealed under corrugated iron in the early 1900s. The original name was Docking but there were many misspellings in the parish registers. They were the last in line here where a bungalow marks the spot.

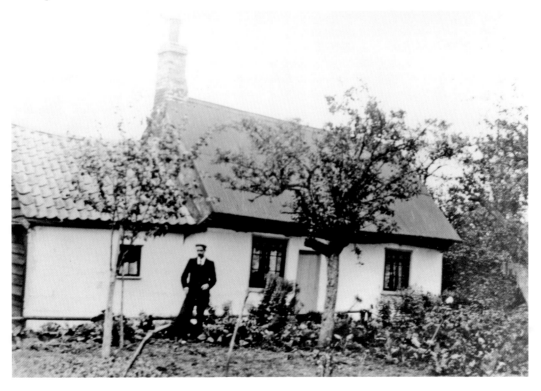

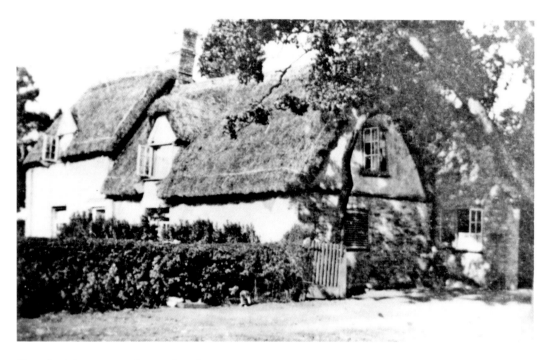

Thatched Cottage on Lower Road

Weep again, Emma, as I could do, for the loss of this thatched farmhouse by the Lower Road, for my family were the last to live in it. Overlooking Soham Mere, it was last occupied by Elijah Harding who married my father's sister. I spent Christmas hours in it until 1930. When we returned in 1931 it had gone, replaced by the new building which today is the centre for a successful vehicle repair service.

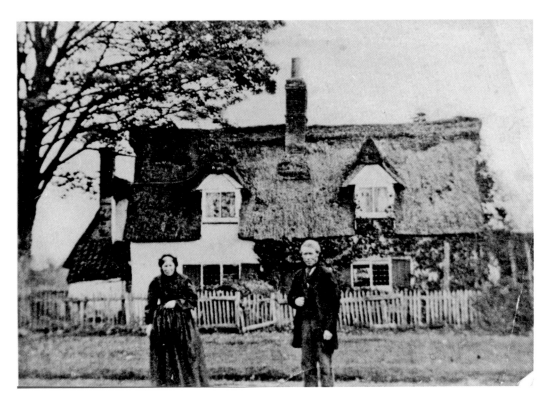

Sycamore Cottage

Sycamore Cottage above Pond Green was divided for two families here in the 1890s, the couple shown being the parents of one tenant, wife of Mark Bailey, turf merchant and farmer. In 1903, the cottage was replaced by the present building, also named Sycamore Cottage, its comparative severity well mitigated today by its owners.

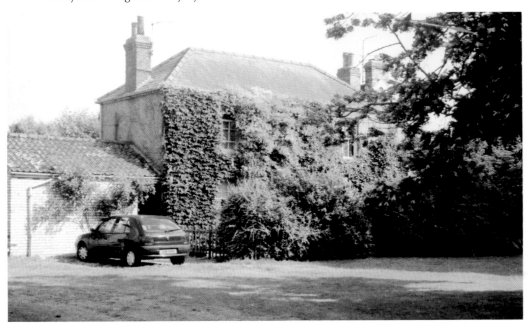

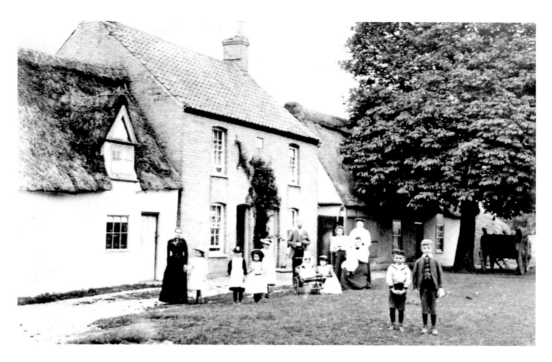

Cottages on Maid's Head Green

Dated 1894, this Emma Aspland view of cottages facing the Maid's Head green includes, behind the horse chestnut tree, the shop and sometime post office owned by Bill Norman, who was also a turf merchant. His drainage mill was the one that provided the model for the mill now in Wicken Fen. Post Second World War, the tree was felled after an insurance dispute and the cottage, left, was replaced in 1913. The shop ended up as an antique business.

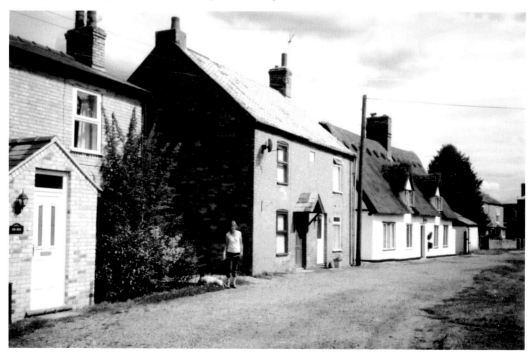

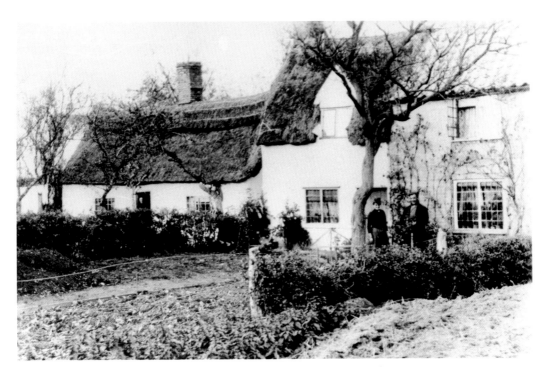

Changing Housing

Then and now can show shattering contrasts and the changes here at the top of Chapel Lane speak loudly of soft to hard. Emma Aspland lived nearly opposite the site and was spared the replacements. John Sewell and his wife stand before their home sweet home. The sun mocks those of today.

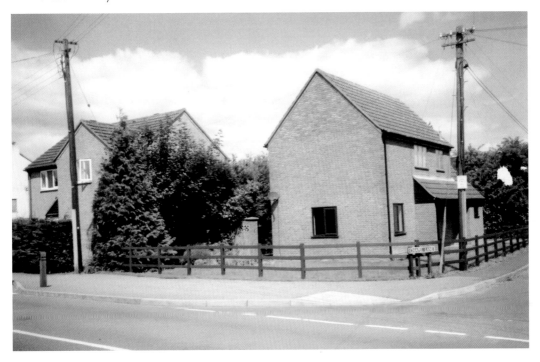

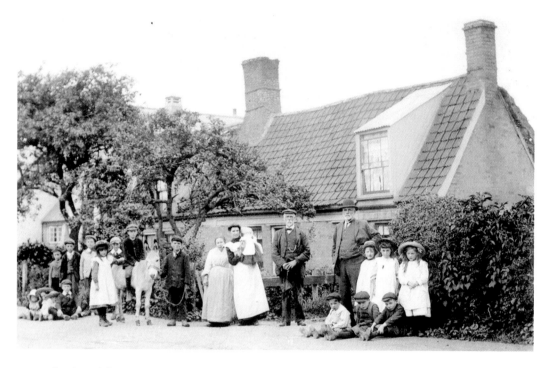

A Sunday in Wicken

This cottage by the school was demolished very recently and was indeed too far gone to survive. The two elderly men were sons of a Wicken emigrant to Australia who had called out Gillson, the photographer of the day, *c.* 1910, for their souvenir trophy. It had to be Sunday to bring the people out. New building began at once, extending to two homes, impressively designed and placed, weathering to come later.

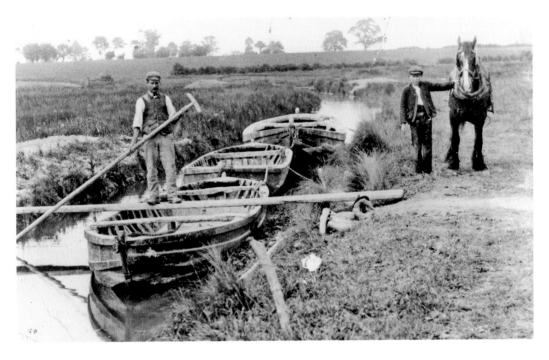

Turf Boat

While the turf business was still thriving there was much activity on the lode and river banks where the boats were pulled by donkeys or, like these of *c.* 1910, a horse for a heavy load. Giles Bailey clings to horse power and George Bullman holds the pole. They were collecting clay from a nearby pit for 'puddling' or sealing the banks where they might leak. Today, the shaven banks are for leisurely walks.

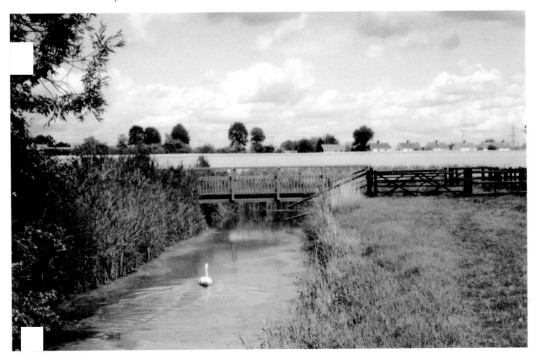

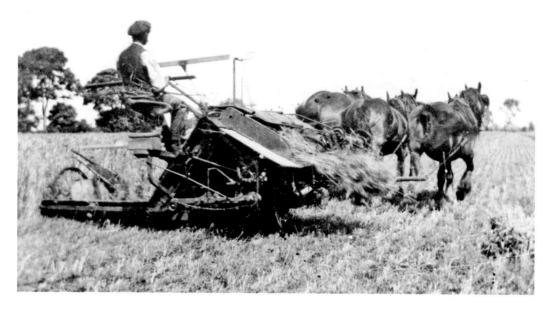

Harvest

Farming was the job at hand for most men and youths until the chemical era sent them away. Today, there are but two farms with a large acreage left in the village with others smaller. Harold Pope, succeeding his father, sits aboard his binder-reaper in 1941 when his son was already working there to succeed him. Today his grandson, David, drives the combine harvester on the same fields, his successor uncertain.

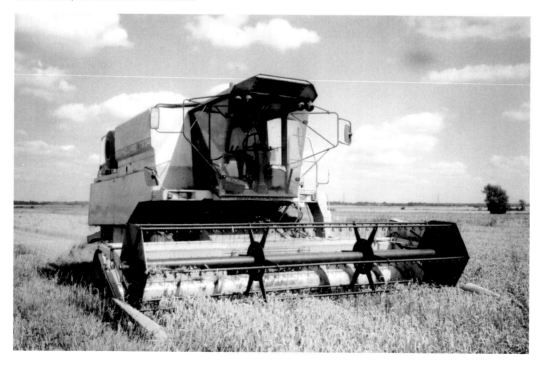

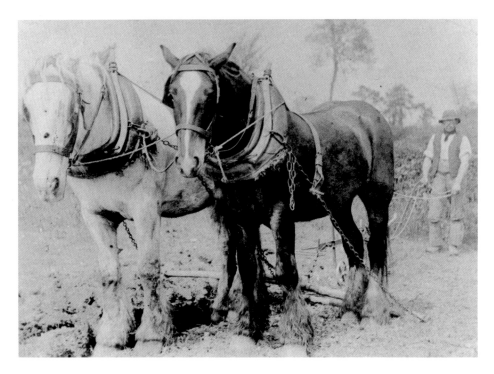

Ploughing

Welcoming the respite, two horses and Jack Hawes the ploughman face the camera *c.* 1912 on the Hall Farm estate. Today's ploughman, Brian Avey, is under cover taking four furrows at a time where some farms use eight for their enlarged fields. Ploughman's legs are a thing of the past. Ploughman's derrière?

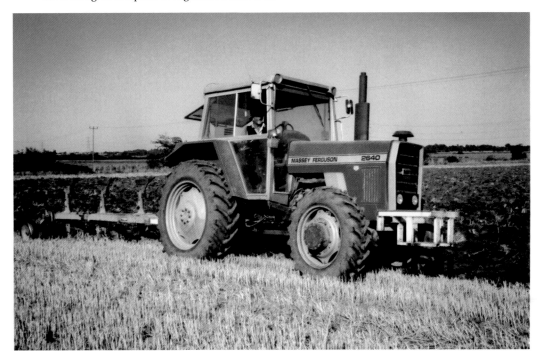

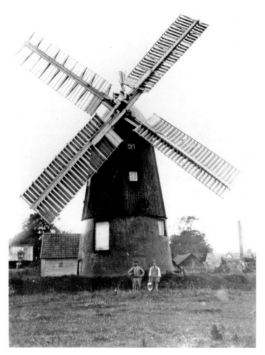

Wicken Corn Mill

Wicken corn mill began its service to local farmers in 1813, John Howe the first miller. It is one of only two twelve-sided smock mills in the land, and its owner in 1908, Woollard Barton, stands before it holding the scoop. He was succeeded at the mill by his son who saw its era out during the Second World War. It was retained as a store but the new owner, George Johnson, sold it to a group of dedicated mill restorers. It took nearly twenty years to get it back to full working order for special open days, a triumph for the village.

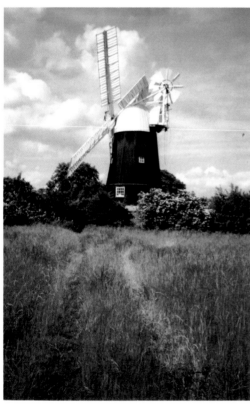